XXL

German and English translation rights are arranged with Olo Éditions through Manuela Kerkhoff – International Licensing Agency

Credits on page 176

Library of Congress Control Number: 2014938024;
British Library Cataloguing-in-Publication Data: a catalogue record for this book is available from the British Library; Deutsche Nationalbibliothek holds a record of this publication in the Deutsche Nationalbibliografie; detailed bibliographical data can be found under: http://www.dnb.de

Prestel books are available worldwide. Please contact your nearest bookseller or one of the above addresses for information concerning your local distributor.

Prestel Verlag, Munich
A member of Verlagsgruppe Random House GmbH

Prestel Verlag
Neumarkter Strasse 28
81673 Munich
Tel. +49 (0)89 4136-0
Fax +49 (0)89 4136-2335

Prestel Publishing Ltd.
14-17 Wells Street
London W1T 3PD
Tel. +44 (0)20 7323-5004
Fax +44 (0)20 7636-8004

Prestel Publishing
900 Broadway, Suite 603
New York, NY 10003
Tel. +1 (212) 995-2720
Fax +1 (212) 995-2733

www.prestel.com

AUTHORS: Éléa Baucheron and Diane Routex

EDITORIAL DIRECTION OF THE FRENCH EDITION: Nicolas Marçais

ARTISTIC DIRECTION: Philippe Marchand

EDITORIAL SUPPORT: Capucine Viollet

LAYOUT: Prestel Verlag, based on the design by Marion Alfano

THANKS TO: Thierry Freiberg for his attentive look

EDITORIAL DIRECTION: Claudia Stäuble

PROJECT MANAGEMENT: Dorothea Bethke

TRANSLATION FROM FRENCH: Susan Haynes-Huber

TYPESETTING AND COPYEDITING: VerlagsService Dr. Helmut Neuberger & Karl Schaumann GmbH, D-85551 Heimstetten

COVER: Florian Fronholzer

PRODUCTION: Astrid Wedemeyer

PRINTING AND BINDING: Tien Wah Press, Singapoure

Verlagsgruppe Random House FSC® N001967
Printed on FSC®-certified paper Titan MA produced by Hansol Paper Co., Korea

ISBN 978-3-7913-4982-4

Éléa Baucheron
Diane Routex

XXL

**WHEN ARTISTS
THINK BIG**

PRESTEL
Munich · London · New York

This book proposes to examine the great names in modern and contemporary art by looking at them from an unusual angle: their size. Although the subject is not new, it is one largely unexplored by art historians, despite the fact that every epoch has had its sculptures, paintings and frescos of imposing dimensions.

The monumental works which first saw the light of day in previous centuries were created with other aims than those of today. In former times, art on a gigantic scale was reserved exclusively for the gods and those in power. The Leshan Giant Buddha (8th century), 71 metres high, the Nazca Lines (created over a period of one thousand years, beginning in 500 BC), with figures spanning up to 275 metres, or the Gothic Minster in Ulm (begun in the 14th century), with its 150-metre steeple, are some of the largest historical religious monuments. People are fascinated by works on such a magnificent scale, and particularly by their spectacular visual impact. Antiquity already defined the Seven Wonders of the World, and all of them, from

the Colossus of Rhodes to the Great Pyramid of Giza and the Lighthouse of Alexandria, are of colossal dimensions.

What drives artists to create gigantic works of art today? In most cases, they are not prompted by religious motives or admiration for those in power, but by the desire to offer a new aesthetic experience. Whether the aim is to increase the visibility of the work, to prove technical prowess or to convey a message, monumental art is never anodyne. In a world over-saturated with images, works in XXL format are a sure way to grab attention.

It is surprising that so many of these works are temporary installations, rendered immortal only by preliminary sketches, photographs or videos.

More than any other form of art, monumental art prompts a dialogue with space, whether it is installed in the countryside, in the streets of our cities or within the confines of museums. The spectator, suddenly rendered minuscule, finds his perception of the world altered.

ART IN THE COUNTRYSIDE

CONQUERING THE CITIES

PUSHING THE BOUNDARIES

TRANSFORMING THE MUSEUM

ANISH KAPOOR

ARMAN

BERNAR VENET

DAVID MCCRACKEN

HUANG YONG PING

JEAN DUBUFFET

JEAN VERAME

ART IN THE COUNTRYSIDE

JIM DENEVAN

MEHMET ALI UYSAL

NILS-UDO

ROBERT SMITHSON

STUART MURDOCH

TOMIE OHTAKE

Generally, art (from the Latin *ars*, "craft, technical skill," from which the words "artisan" and "artifice" are derived), is seen as the opposite of nature, as innate creation existing without human intervention. At first, fascinated by the perfection of life, man attempted to imitate it in works of art. But in the late 1960s, a new development took place: the desire to break out of the confines of the art market led artists to leave the hallowed space of the museums and galleries and install their art in a natural environment. Robert Smithson (see pages 28–29), pioneer of *land art*, expressed his dissatisfaction with the paralysing effect of institutions: "The museum undermines one's confidence in sense data. […] Art settles into a stupendous inertia […], things flatten and fade." Numerous artists, seduced by this new vision, which altered the relationship between art and nature, followed in his footsteps. Thus, the landscape itself became part of the ultimate form of the work: art *in situ* was born. The movements were given names such as *land art*, *earth art* or *environmental art*, and their proponents—artists like Dennis Oppenheim, Nancy Holt, Robert Morris, Walter De Maria…—used natural materials to create ephemeral works of art which survived only in the form of photographs or videos.

The *land art* movement often produced works of monumental scale. By taking nature as their canvas, artists were able to play with volume, mass and space in a way which would never have been possible within the confines of a museum or in an urban setting. Ravines, mountains, a strange, pink-coloured lake … The following chapter will show that these grandiose elements of nature served both as a canvas and setting for artists in search of the exceptional.

Other artists used the countryside as a backdrop for works of art which were not made from natural materials. For example, Jean Dubuffet (see pages 16–19) left the urban environment, not in order to work on and with nature but in order to find the necessary space to create and exhibit their artworks, the dimensions of which could not be accommodated within the walls of a museum or gallery.

But nature can not only contribute to the beauty of a work of art and provide access to vast open spaces; it can also serve to democratise art, to make it freely accessible and visible to all. The sand sculptures created by Jim Denevan (see pages 40–43) or the *Serpent d'océan* by Huang Yong Ping (see pages 36–37) will never be hung on the walls of a museum.

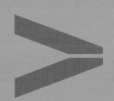

Pages 12–13:
Anish Kapoor (see pages 158–161)
Dismemberment Site I, **2009,**
25 × 85 m, stainless steel and PVC, Gibbs Farm, New Zealand

Pages 14–15:
Jim Denevan (see pages 40–43)
Untitled, **2010,** Lake Baikal, Russia

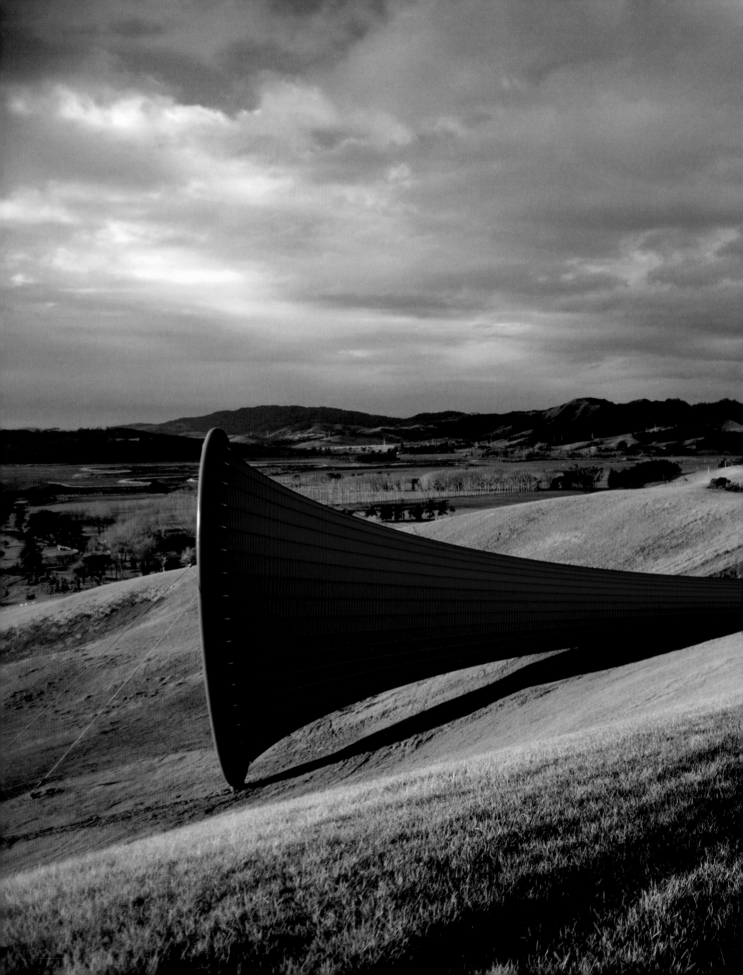

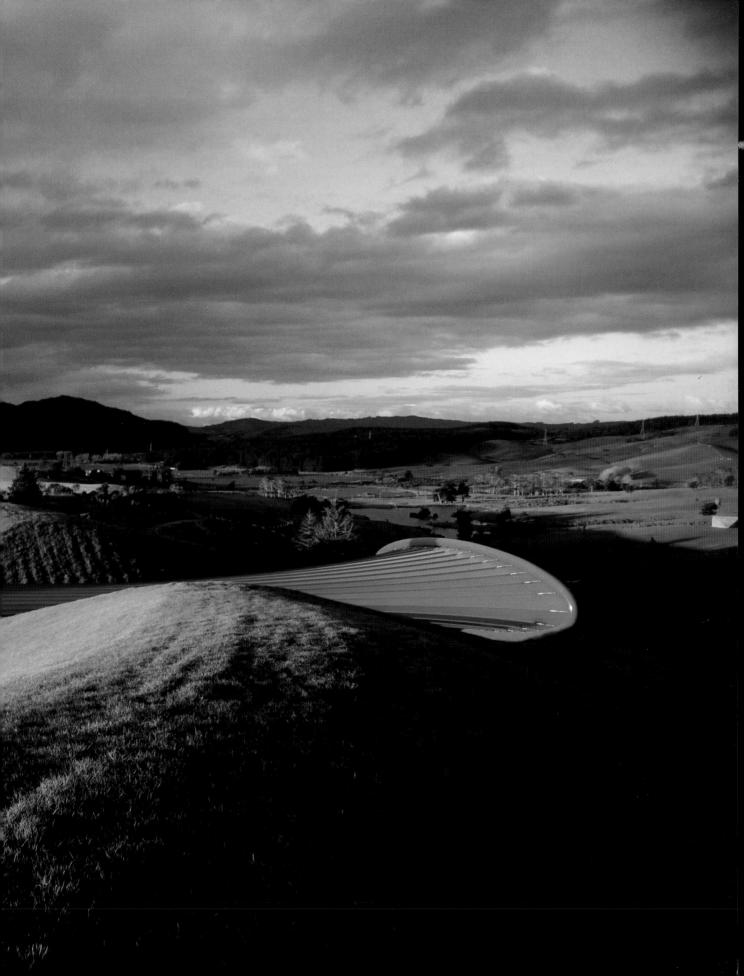

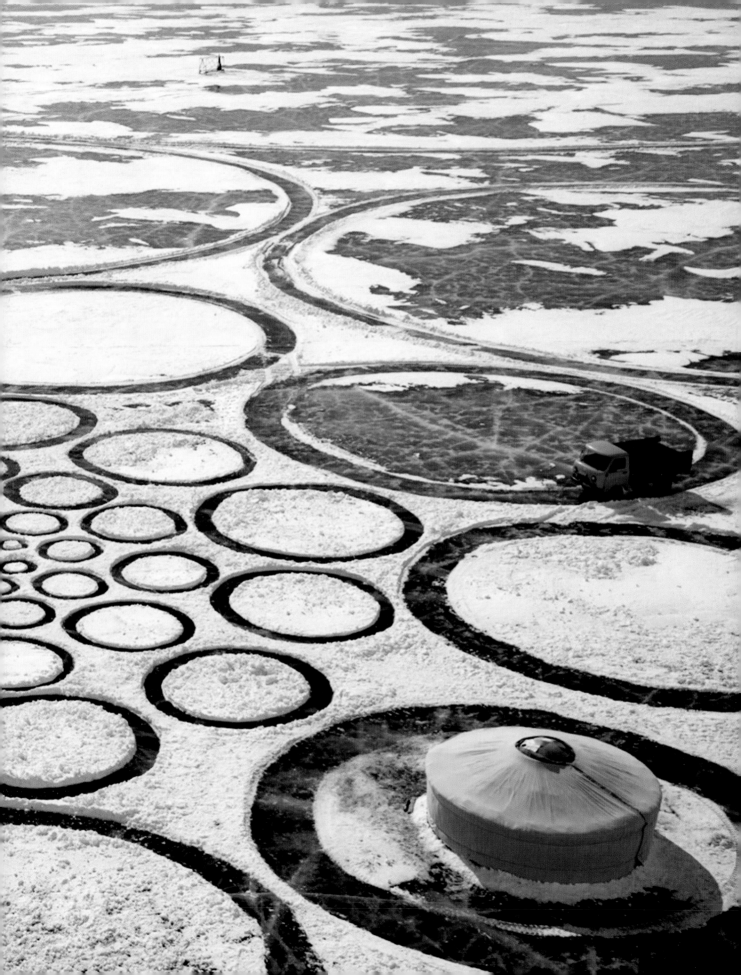

JEAN DUBUFFET

(1901–1985)

Multi-talented Jean Dubuffet was a painter, sculptor and graphic artist. He invented the term 'l'art brut' (raw art by non-professional artists), an art stripped of intellectual concerns, advocating a return to the more immediate and spontaneous. His works are varied and intriguing, for example the amazing *Closerie Falbala*, an architectural sculpture measuring 1610 square metres!

At the age of 61, Dubuffet began a new cycle of his work, which he called *L'Hourloupe*. Again, he invented this term himself, and it denotes the longest and without doubt the most original period of his career as an artist. The cycle began with drawings and paintings. Dubuffet then discovered a new material, expanded polystyrene, which can be easily sculpted with the aid of a heated wire. He used this method to create the models for his sculptures and architectural works. With *L'Hourloupe*, Dubuffet created a surprising universe which intrigues the viewer, fires the imagination and prompts us to reconsider our view of the world.

In 1971, he began construction work on the *Closerie Falbala*, which was completed in 1973, entirely at his own expense. Built near Paris, it is not far from his sculpture workshops and the stores for his materials. It is made from concrete and epoxy resin, painted white and highlighted with black lines. Walls enclose the *Villa Falbala*, which contains a room for meditation and contemplation with a huge painting completely covering its walls: he called this room the *Cabinet logologique* (another neologism). The word comprises the repetition of "logos" (an Ancient Greek word meaning different things in different contexts). A new attempt by the artist to poke fun at intellectualism? If that is the case, it could be said that the idea of devoting a chamber to philosophical reflection is ironic, an irony that is mirrored in its nonsensical name. The room has no windows, only one door and is decorated with a painting which the artist had completed some years previously. The *Closerie* was designated a historic monument in 1998.

Above:
The *Closerie Falbala*, 1973, 1610 m², concrete and epoxy resin, Périgny-sur-Yerres, France

Following double page:
Antichamber of the *Villa Falbala*, 1976, view into the *Cabinet logologique*, 1969, through the open door, Périgny-sur-Yerres, France

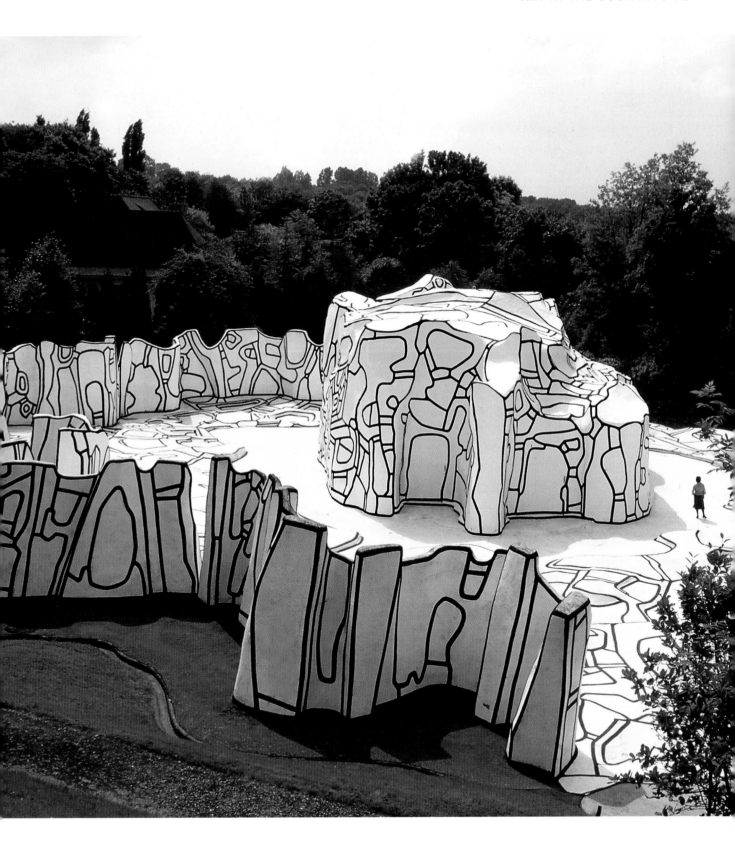

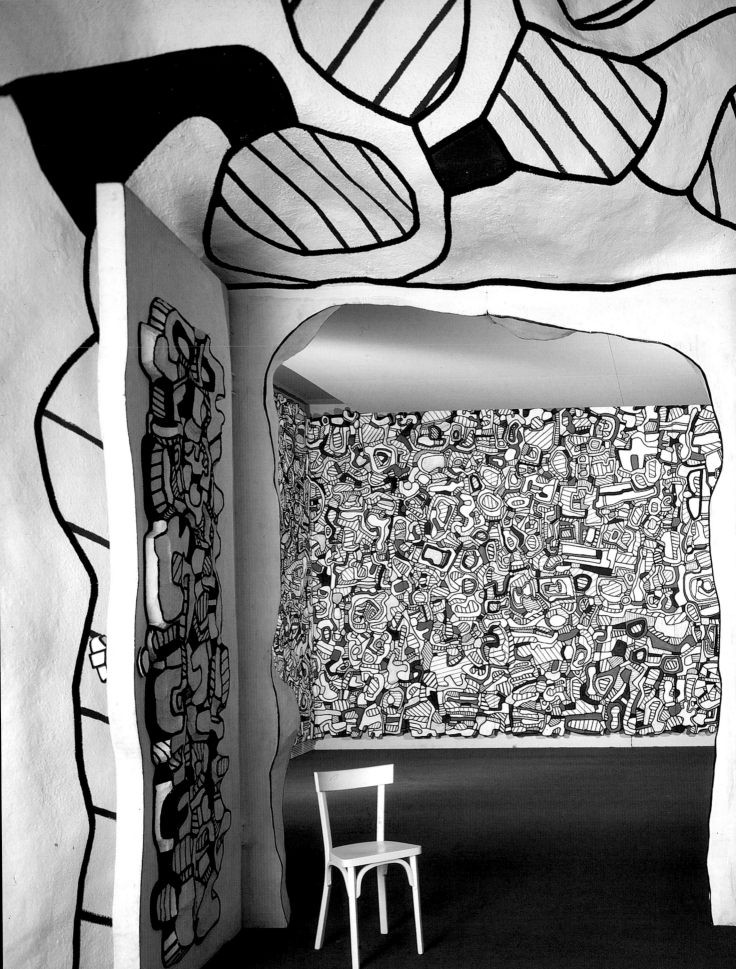

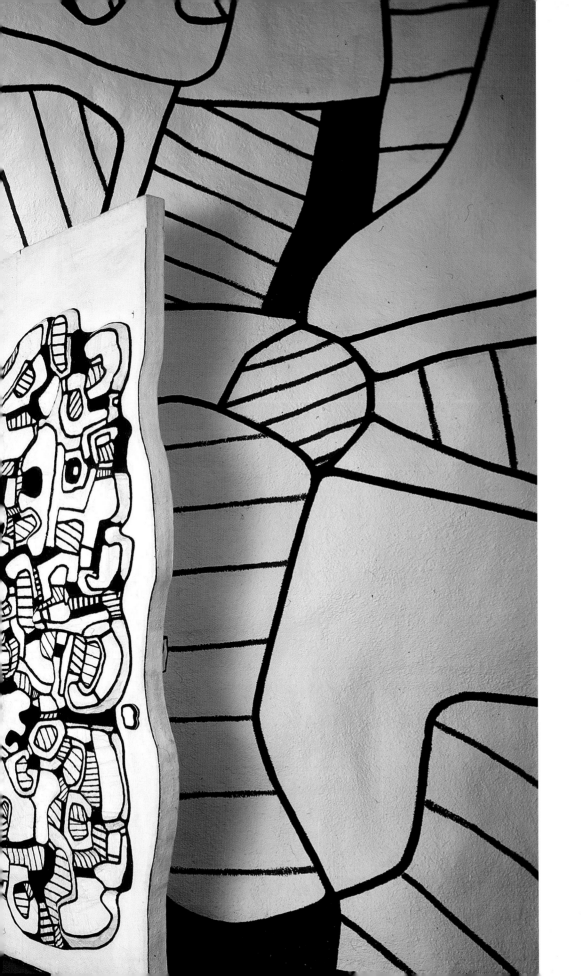

TOMIE OHTAKE

(b. 1913)

Did you know that Brazil has the largest Japanese population outside Japan itself? The first immigrants arrived in the port of Santos in 1908, following an agreement between the Japanese government and that of Brazil, where there was a shortage of labour. Today, 1.5 million people of Japanese origin live in Brazil. To celebrate the centenary of the arrival of these first immigrants, Tomie Ohtake was invited to build a monumental sculpture in Santos.

Born in Japan, Tomie Ohtake travelled to Brazil to visit her brother at the age of 23, eventually settling there and becoming a naturalised Brazilian. Initially interested in painting, she later turned her hand to sculpture, always favouring abstractionism, and she is recognised as one of her adopted country's major artists. There is an art institute bearing her name in São Paulo; it presents new trends in Brazilian art as well as international artworks and works from the last fifty years (a period corresponding to Tomie Ohtake's artistic career). She celebrated her 100th birthday in November 2013 and was 94 years old when her work was created in Santos. The steel sculpture, which celebrates the arrival of the first immigrants and the bond of friendship between Japan and Brazil, was inaugurated by the heir apparent to the throne of the Empire of the Rising Sun, Prince Naruhito.

AROUND 80 TONNES OF STEEL WERE USED TO CREATE THIS SCULPTURE, WHICH IS 15 METRES HIGH AND 20 METRES WIDE.

Tomie Ohtake offers no explanation regarding the form and colour of her work, but it is easy to imagine that the bright red of the sculpture is a reference to the red circle of the Japanese flag. Nevertheless, the sculptor affirms that although voyages and Japanese immigration have always been subjects very important to her, she prefers to let everyone interpret her sculpture as they see fit. She refuses to name her works, for fear of influencing the spectator. Those who still want to name the red sculpture termed it "Monumento," which simply means "monument." The installation in Santos faces the sea so that ships arriving in the bay can see it. With its bright colour and colossal dimensions, it appears like the beacon of a lighthouse, a symbol of welcome for new arrivals.

Untitled, 2008,
15 × 20 × 2 m, steel, Santos, Brazil

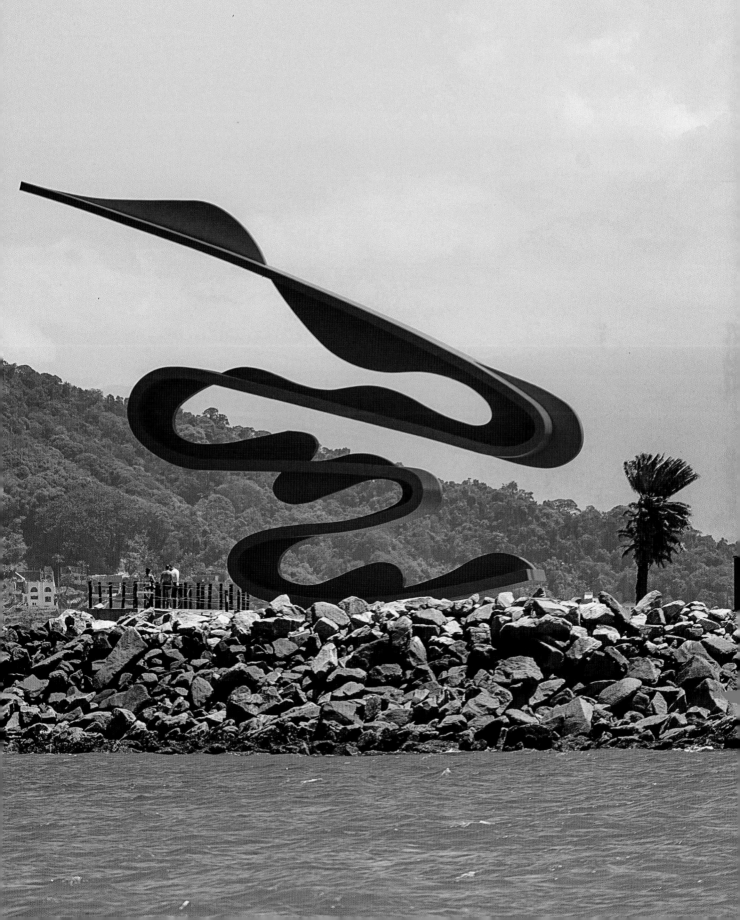

ARMAN

(1928–2005)

In the 1960s and 1970s, the New Realist movement was examining the place of art within a consumer society. Arman, one of the leading representatives of this group, was among the first to use everyday, mass-produced articles in his work. He accumulated such objects, dismantled them into their component parts, enclosed them in cement… a type of artistic recycling which brought art and everyday artefacts closer together and lent the mundane an aura of aestheticism.

In the late 1960s, Arman became preoccupied with industry — he collaborated with Renault — and with accumulations of large numbers of identical objects encased in concrete; he was soon internationally successful. In 1976, he had the idea for a work comprising real cars embedded in a tower of concrete. Despite his enthusiasm, the project went no further, as potential patrons were discouraged by the scale and cost of the proposed work. Six years later, he met Jean Hamon, director of an industrial construction company, who assured him that "nothing is impossible." And so the two men decided to build a trial object, several metres high, in the park of the château de Montcel, which Hamon had purchased. A wooden mould against which the cars were wedged was set up on a concrete base measuring eight by eight metres. At its centre, there was a hole measuring one square metre by which it was possible to descend into the heart of the sculpture. The outer surfaces of the cars were sprayed with insulating material to protect their paintwork against the concrete, which was now poured into the mould, filling and encasing the cars; once it had dried, the layer covering the vehicles and the mould were removed. This trial proved so successful that Arman no longer felt restricted by the envisaged height and constructed a tower measuring 19 metres from top to bottom. Despite some protest, *Long Term Parking* was installed permanently in the park. The artist expressed his intention that it should be left to the ravages of time until the cars disappear, leaving only their imprint in the concrete.

Long Term Parking, 1982,
19.5 × 6 m, cars and concrete, Château de Montcel, Jouy-en-Josas, France

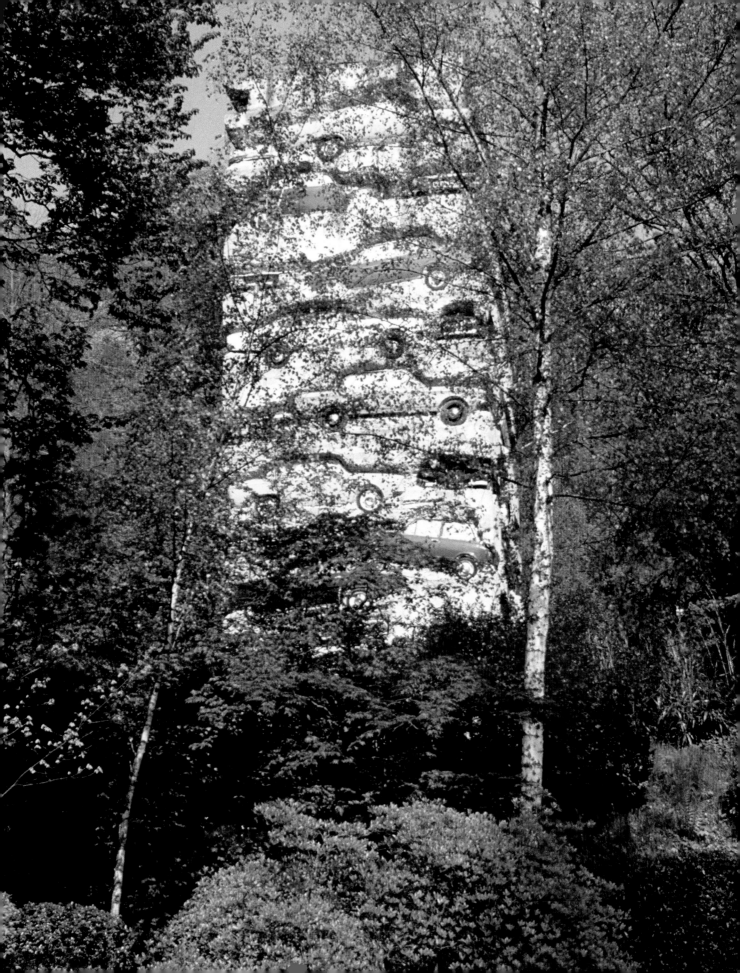

NILS-UDO

(b. 1937)

"Sketching with flowers. Painting with clouds. Writing with water." NILS-UDO composes ephemeral, colourful 'tableaux vivants' which change with the passage of the seasons ... and of life. This German sculptor is fascinated by the possibilities of nature and creates artworks ranging in size from the minuscule to the monumental.

NILS-UDO began his career as a painter, but in 1972, despairing of the inability of this art form to render nature faithfully, he renounced it and started to work "parallel to nature," creating installations in forests, on plains and beaches ... using only the materials he found on-site—leaves, tree trunks and branches, berries, earth, water, kernels, stones, flowers ...—and always taking care not to cause any irreparable damage to the location. He then takes photographs of these transitory scenes, the final step to complete his work. Nature, once imitated by art, becomes the medium itself: he arranges colours and shapes in a way that reveals a hitherto unrecognised aesthetic appeal. By confronting us with the beauty of his creations, the artist introduces us to a new understanding of nature that goes beyond mere contemplation or reflection.

The motif of the nest is central to his œuvre. It appeared for the first time in 1978, made from earth and birch branches, on the Lüneburg Heath in Germany. Other nests in varying sizes and materials followed: nests made of snow, of bamboo, hay, ash, grass, pine branches and moss-covered stones, wicker nesting boxes and real bird's nests with pebbles or snowballs dyed with the juice of wild berries. The nest has a powerful symbolic force: it represents the womb, the cradle and therefore birth. NILS-UDO sometimes photographs children (or himself) posed in foetal position in nests.

The Nest was presented in Munich in 2005, as part of the BUGA, a major horticultural exhibition, and is the largest ever built. The outside consisted of trunks of spruce and willow up to 25 metres in height, while the gravel spread in the centre of the nest represented soft, downy feathers. Visitors were able to "explore" the nest and discover the giant eggs which had been placed inside it.

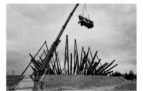

Opposite and following double page:
The Nest, **2005,** height of the longest trunk: approximately 25 m, spruce and willow trunks, gravel, Munich, Germany

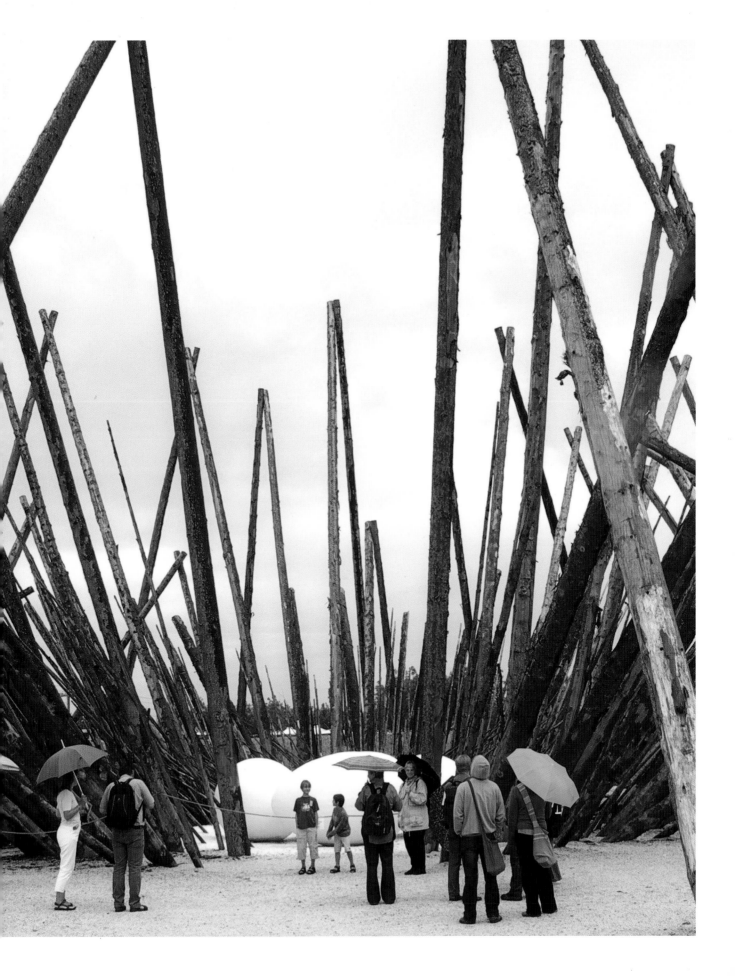

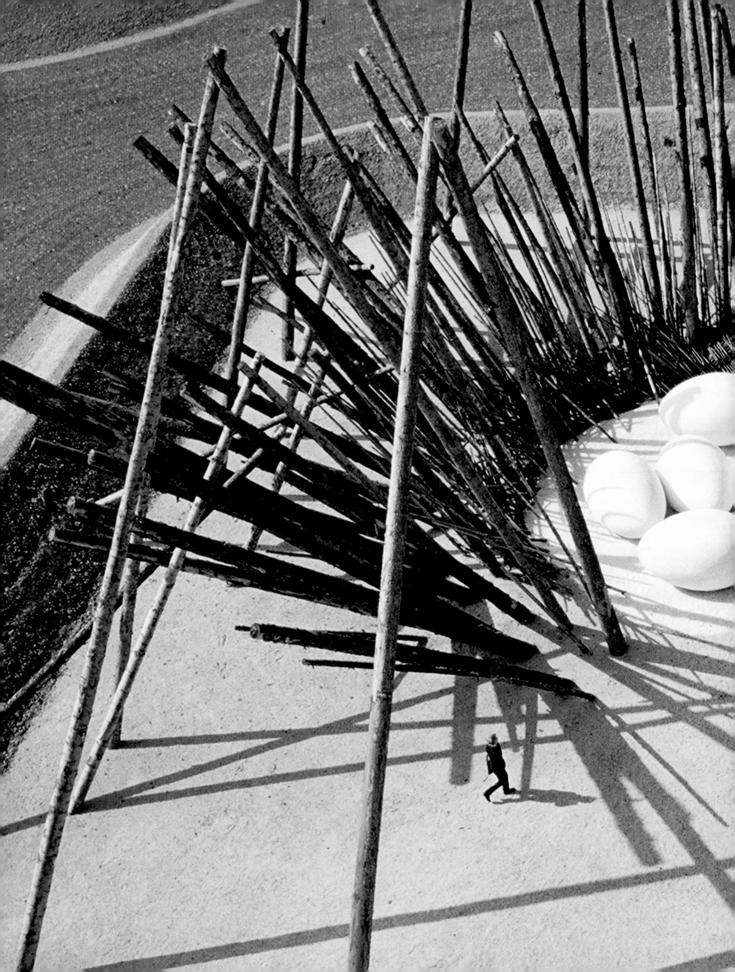

ROBERT
SMITHSON
(1938–1973)

Spiral Jetty appears and disappears from view, alternately revealed and hidden by the water. Robert Smithson chose a unique location which underscores the aura of the spiral for this jetty, which is 457 metres long and 4.5 metres wide.

The Great Salt Lake is located in the United States and is famous for its unusual pink colouring, which is a natural effect produced by micro-organisms. On the shores of the lake, the remains of abandoned industrial buildings symbolize the passage of time and the impact of human activity on the environment.

Smithson's work also transforms the landscape. Just like the ruins around it, it is a creation abandoned to the whims of nature. The spiral was built during a relatively dry period. Then, two years later, as the climate became more wet, the water rose and covered the jetty, which has remained mainly submerged for more than 30 years now. In recent years, it has reappeared periodically, always subject to the caprice of the lake water. Smithson was fascinated by the inconstancy and uniqueness of this location: in addition to its aesthetic attraction and the changing level of the lake, the site inspired the form of Spiral Jetty: "the site was a vortex, bound in an immense circular movement. Spiral Jetty was born in this whirling maelstrom. No idea, no concept, no system, no structure, no abstract principle could stand in the face of this evidence," he explained. Add to this the fact that the salt crystals of the lake also have a spiral shape, and it becomes clear that the vortex form was inevitable. These salt crystals were used during the construction of the jetty, as were other natural materials found on-site, for example mud, basalt, wood and water. The colour of the lake, the various elements it picks up and deposits on its banks form part of the work, which in itself is an integral part of the landscape that surrounds it. And so one might wonder whether Spiral Jetty should be preserved or left to its own devices, at the mercy of time and the elements, in keeping with its essence. No-one knows what fate Smithson had in mind for his work. He died in a plane crash three years after its completion.

Spiral Jetty, 1970,
457 × 4.5 m, mud, earth, rocks, salt crystals, Great Salt Lake, Utah, United States

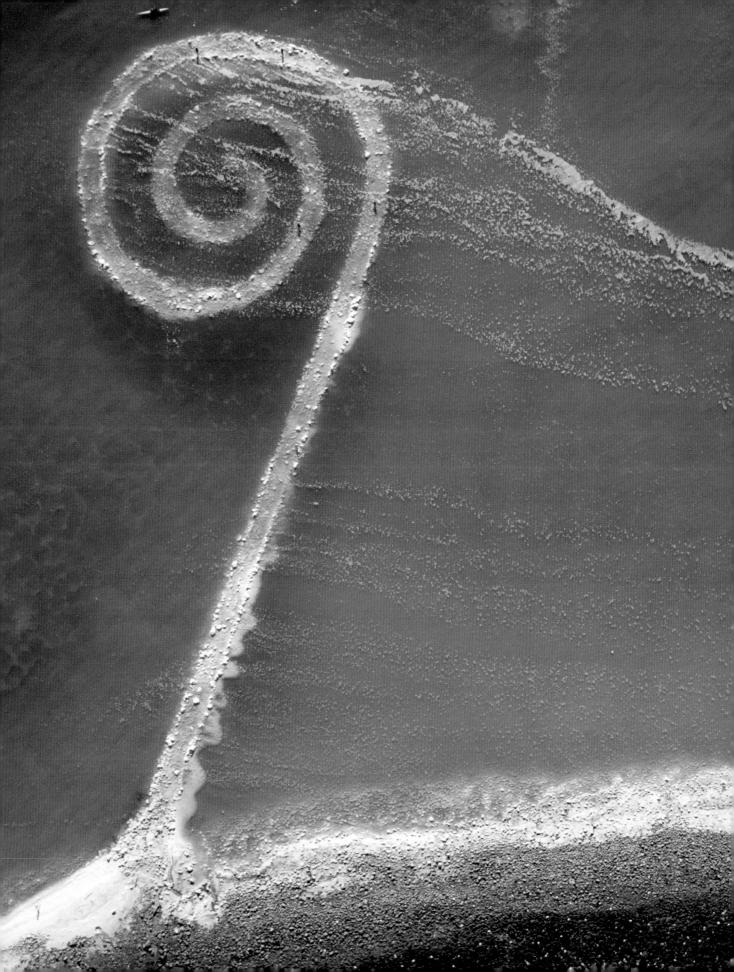

JEAN
VERAME
(b. 1939)

Jean Verame is the creator of unprecedented works within the *land art* movement: he paints directly on desert rock. His vast projects take several months to complete and require years of meticulous preparation.

Jean Verame began to paint on stone in 1975 in the Cévennes mountains. Soon, this Belgian-born French sculptor felt the need to work in an uninhabited region, where his work would disturb no-one, and decided to move into the desert. In 1981, he created his first large-scale work in situ in the Sinai; this was to be the first in a series of many vast 'open air workshops.'

In 1987, he travelled to the Tibesti desert in the north-east of Chad and spent several weeks searching for a site which sent out the right "flow, waves, call it positive, sensual vibes." He found the perfect location: a circular area, almost two kilometres in diameter and surrounded by rocks, at an altitude of 1,200 metres. Then he set about making his preparations. This was an undertaking of colossal proportions and took almost two years: after obtaining the official permits required, he not only had to transport all the painting materials he needed to the site (1,500 canisters, each weighing 20 kilos, of paint manufactured specially for this project, paint sprays, compressors, scaffolding, etc.), but also several months' worth of supplies for a whole camp (tents, food, petrol, etc.). Jean Verame worked there from March to June 1989: using spray pistols, he painted large patches of blue, red, black, violet and white on rocks, some of which were 30 metres high. Although his work rarely features motifs, in Tibesti, the "painter of deserts" created a labyrinth pattern made of small rocks painted blue. Verame states that when he looked at the collection of large, monochrome rocks, he felt the need to show that for him, it was the experience of the desert that counted, not any sense of himself as being at the centre of the labyrinth. Jean Verame nearly died of dehydration during this gruelling adventure in the Tibesti desert. However, this did not stop him completing his work and signing it, as is his custom, by writing his name in the sand.

> **" I SET OUT TO ACCOMPLISH MY PURPOSE IN BECOMING AN ARTIST; TO EXPRESS MYSELF, LIBERATE MYSELF, TO CREATE AND INVENT WITHOUT CONCERNING MYSELF WITH RULES, SCHOOLS, LAWS, GENRES, PRECEDENTS, PERMITS AND THE EMPTY STRIVING FOR HONOURS. "**

Above and following double page:
***Untitled*, 1989,** various dimensions, paint, Tibesti, Chad

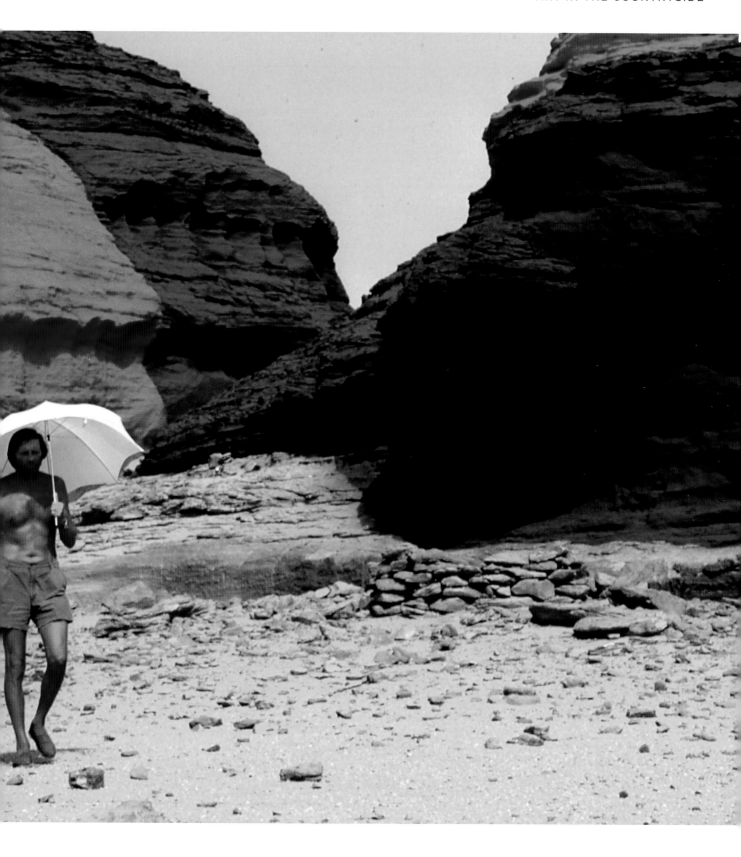

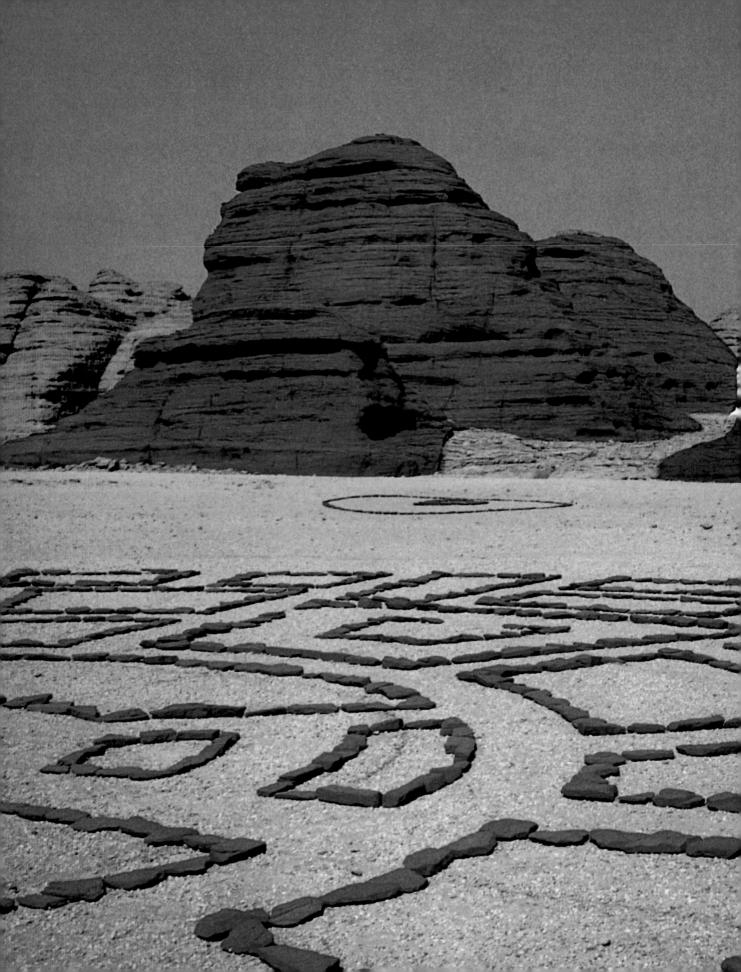

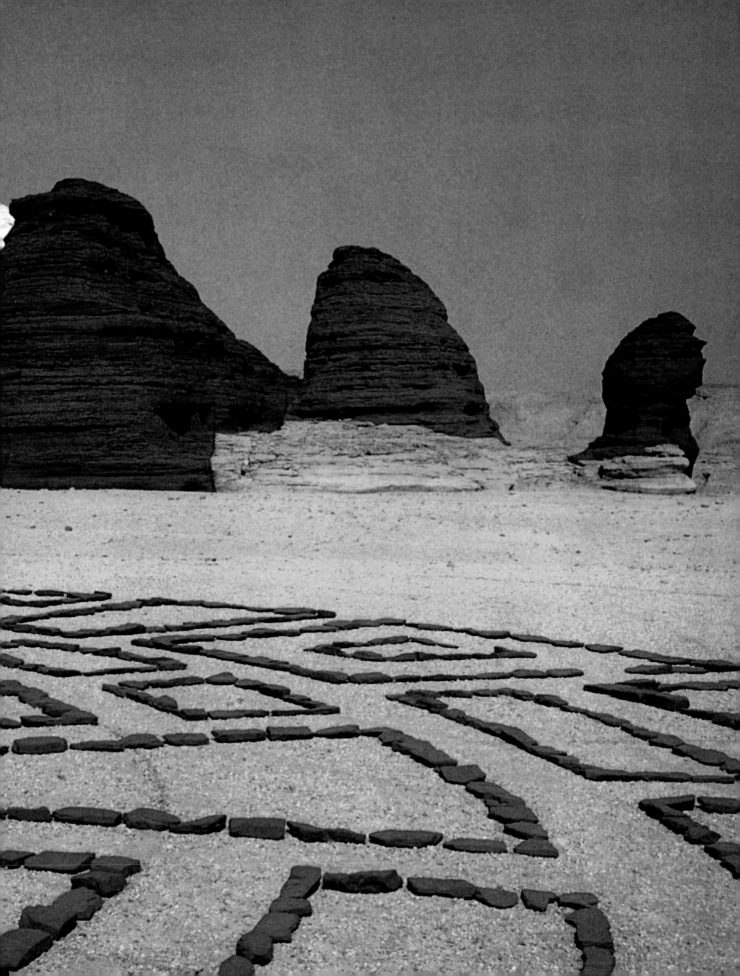

BERNAR VENET
(b. 1941)

French artist Bernar Venet began his career in New York in 1966. He was encouraged by great sculptors such as César (see pages 60–61) or Arman (see pages 22–23), paying tribute to the latter by also dropping the final "d" in his first name (calling himself Bernar rather than Bernard). Today, he exhibits all over the world, and his famous curving steel sculptures can be seen outdoors, indoors, in urban or rural surroundings.

Venet's artistic calling was apparent from his childhood and goes hand in hand with a passion for mathematics which finds expression in the geometric austerity of his sculptures and in the names he gives them: *88.5° Arc × 8* is a reference to the dimensions of the work.

88.5° Arc × 8 is made up of eight arcs and has an airiness which belies the fact that it is made of an alloy of copper, nickel and chrome known as Corten steel. This monumental sculpture can be found at Gibbs Farm, a park in which a major art collector brings together sculptures realised by well-known artists *in situ*, for example Koons (see pages 68–69). Venet displays a sensitivity to the beauty of light striking the brown steel, in particular the rays of the rising and setting sun in New Zealand, where *88.5° Arc × 8* is installed. Located in an extensive park by the sea, the work has the air of a huge tree, bent by the sea winds, its lines forming a contrast to the flatness of land and sea. Transcending the grassy plain, it rises to transform the horizon. *88.5° Arc × 8* is typical of a large portion of the artist's work. Venet has created a whole series of similar yet distinct curved sculptures in Corten steel. In 2011, for example, he presented *85.8° Arc × 16* at the Palace of Versailles. Inspired by the location, he imagined two arcs framing the façade of the building and a statue of Louis XIV. Like a showcase, the sober, elegant lines of Venet's work enhance both natural landscapes and architecture, transforming their perspective.

88.5° Arc × 8, 2012,
27 × 0.75 × 0.75 m, Corten steel, Gibbs Farm, New Zealand

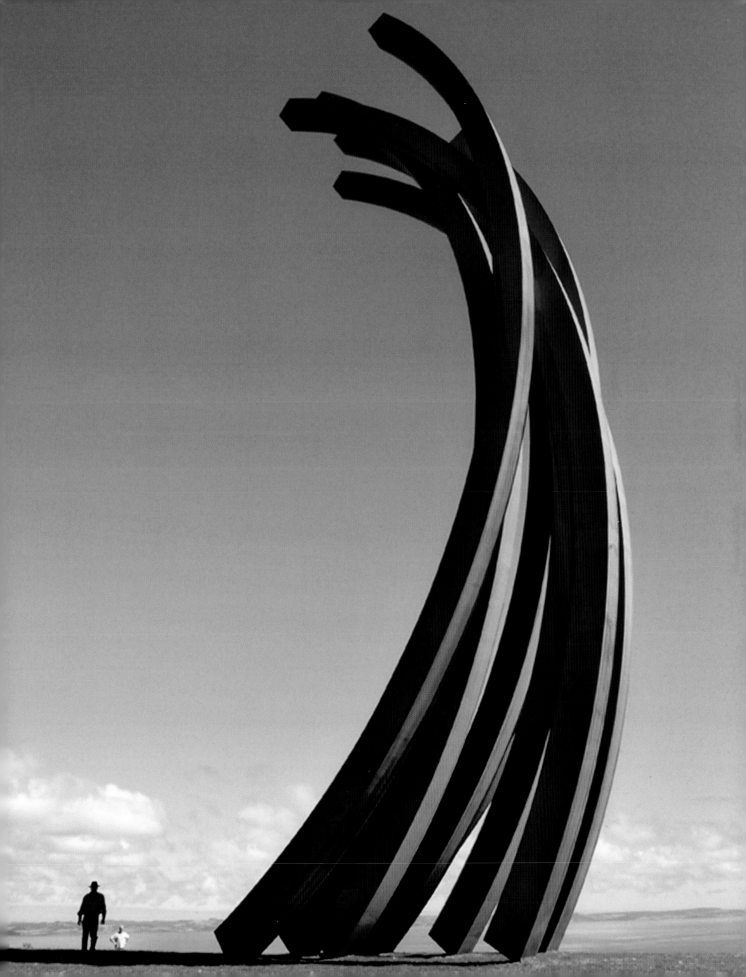

HUANG YONG PING

(b. 1954)

Huang Yong Ping, a sculptor from the Chinese province of Fujian, was one of the early Chinese avant-garde artistes to appear in the 1980s. His works, which can be interpreted in many ways, feature animals and in particular snakes, as their principal motif.

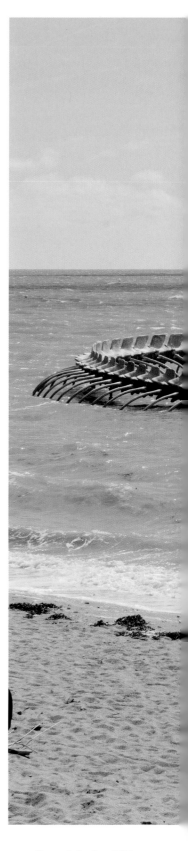

A founding member of the Xiamen Dada, a dadaist group that incorporated elements of Zen Buddhism ("Xiamen" as a reference to the city where he was born), Huang Yong Ping left China for France in 1989 (he became a naturalised French citizen in 1999). In 2012, he created a giant curving sea serpent skeleton with wide-open mouth at the tip of the Nez-de-Chien, near Saint-Brévin-les-Pins (where the river Loire meets the Atlantic). Stretching along the foreshore, the 128-metre-long *Serpent d'océan* appears and disappears with the tide. Huang Yong Ping creates a dialogue between his work and the architecture in the surrounding area: the curve of the skeleton mirrors that of the nearby Saint-Nazaire bridge, while the vertebrae attached to the ribs along its sides are reminiscent of the huts on stilts typical of the region and used by fishermen fishing with dip nets. As a creature which features both in Chinese and Western mythology, the serpent was chosen by the artist as a symbol of the cross-fertilisation of these two cultures. The work also addresses environmental questions: the skeleton, as it is colonised by marine flora and fauna, will be transformed in the course of time.

" I COULD MAKE MUCH SMALLER WORKS: THAT WOULD BE MUCH EASIER! BUT EXHIBITION SPACES TODAY ARE GETTING LARGER AND LARGER, AND SO ARTISTS HAVE TO CREATE ARTWORKS WHICH FILL THAT SPACE. "

The serpent or snake is a recurrent theme in Huang Yong Ping's works: merely as a title (*Reptiles*, 1989) or in a more realistic manner, for example in *Theatre of the World* (1993), a controversial work in which live insects and reptiles enclosed in a vivarium devoured each other. But in particular, *Serpent d'océan* echoes *Tower Snake* (2009), a similar but vertical installation exhibited in the Barbara-Gladstone Gallery in New York.

Serpent d'océan, 2012,
length: 128 m, steel rods and tubing, ribs, vertebrae and head in cast aluminium, Saint-Brévin-les-Pins, France

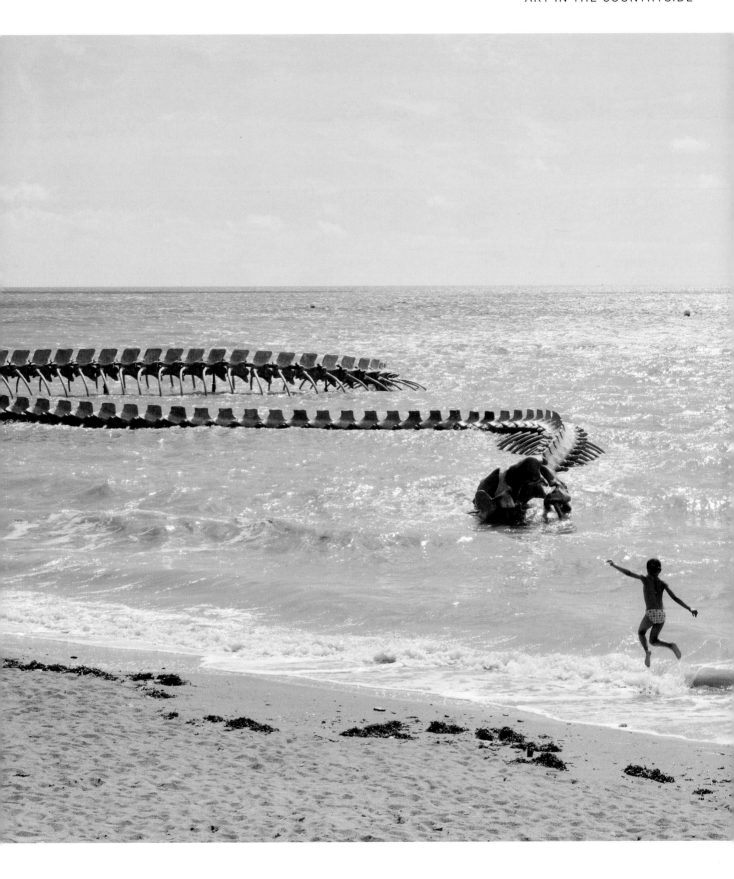

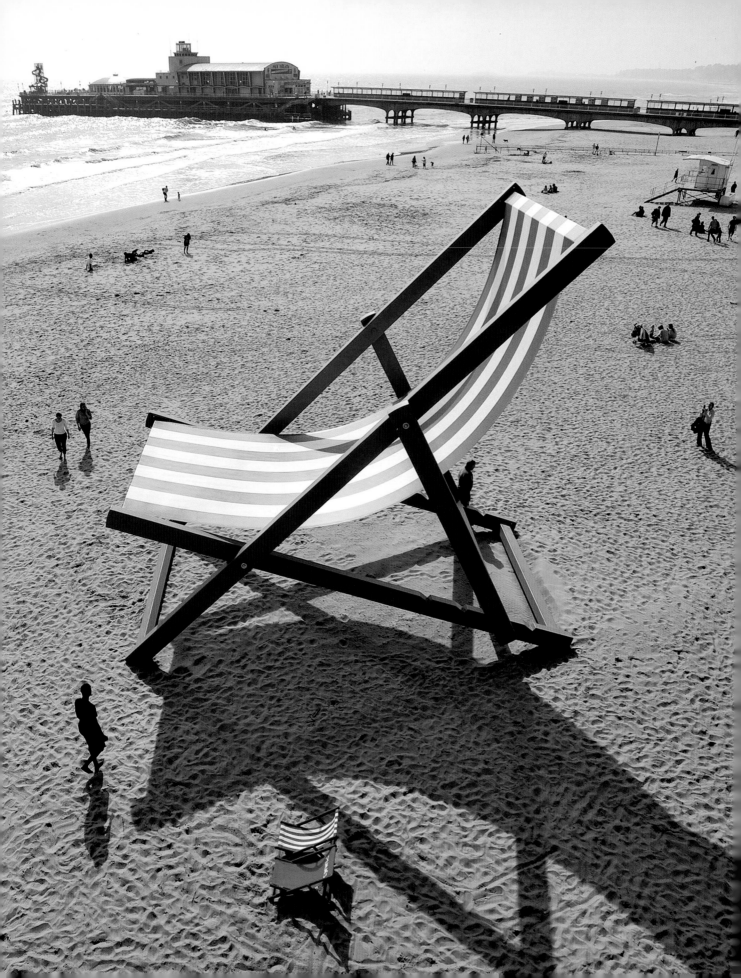

STUART
MURDOCH
(b. 1954)

Create a deckchair taller than a giraffe and weighing more than an adult elephant? This was the challenge taken on in 2012 by British sculptor Stuart Murdoch, who is, by the way, well-known for his monumental works of art.

The main tourist attraction of the town of Bournemouth, which is situated on the south coast of England, is its long beach with fine sand, invaded by hordes of tourists every summer. And on this beach, in March 2012, tourists and locals alike were able to admire the biggest deck chair in the world. Sculptor Stuart Murdoch was commissioned to create this giant recliner by beverage manufacturers Pimm's, whose products are extremely popular in Great Britain, in celebration of British Summer Time. On the last Sunday in March, the clocks are put forward one hour, providing the ideal opportunity for the British to drink to the prospect of the warmer days to come. Once the plans for the project were completed and the materials ordered and delivered, it took the artist three weeks to set up this huge deck chair, which was 8.5 metres high and weighed 5.5 metric tons. Although the sculpture remained in place for only a few days, this "typically British" object, as the artist describes it, certainly drew the crowds.

Stuart Murdoch's works are usually commissioned by well-known companies or organisations. Influenced by his experience as a TV special effects director and working in advertising, Murdoch likes to juxtapose unusual and unexpected materials, creating sculptures which combine humour, art and engineering.

Earlier in 2012, as part of a charity sale to raise money to assist wounded or damaged British military personnel returning from, for example, Afghanistan, Stuart Murdoch created a full-size replica of a Challenger tank, using more than 5,000 egg boxes, 10,000 nails, 26 litres of adhesive, 15 litres of paint, 80 square metres of steel and 5,000 staples!

Pimm's Deckchair, **2012,**
5.7 × 9.7 × 8.5 m, carburised steel, PVC fabric, on the beach at Bournemouth, Dorset, United Kingdom

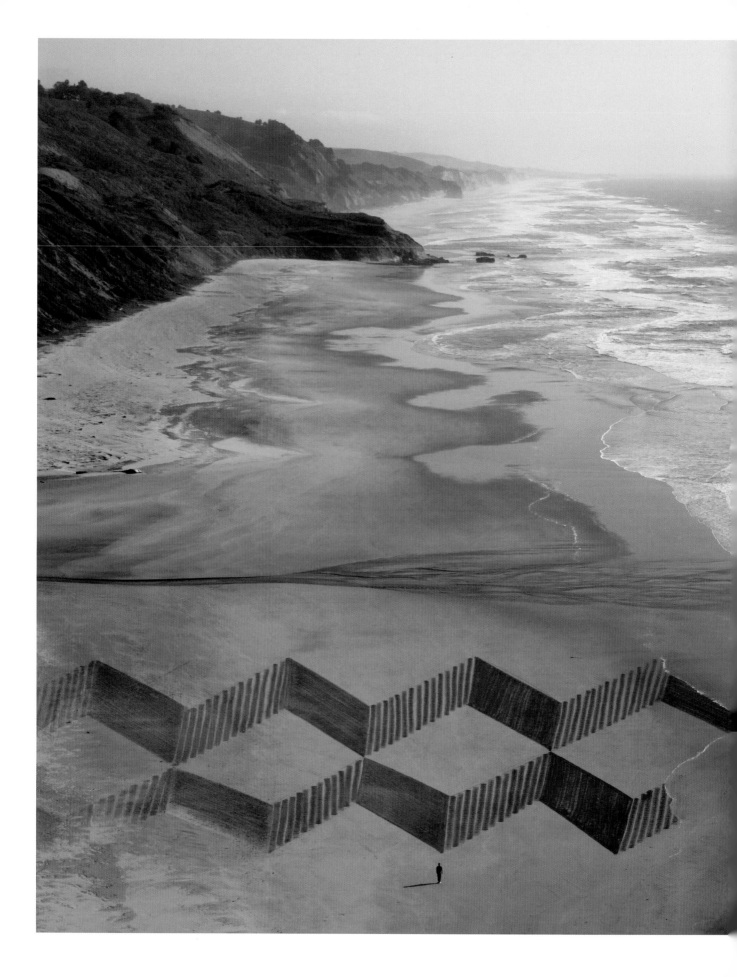

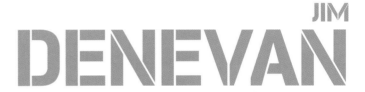

JIM
DENEVAN
(b. 1961)

A master of ephemeral art, Jim Denevan does not even give his works names. Using just a stick and a rake, he sculpts the ground itself into a myriad fragile geometric shapes. And these huge drawings on sand or earth are short-lived, being obliterated for ever by the incoming tide or the next storm.

Following the principles of *land art*, Denevan traces his transitory works outdoors using natural materials and exposed to the elements. He mainly draws on beaches, but also in desert sands, earth or even ice, as was the case in 2010, when he carved huge concentric patterns from the frozen surface of Lake Baikal. In 2008 and 2009, he created a monumental work with a circumference of almost 14.5 kilometres in Black Rock Desert in the United States, using a roll of chain fencing pulled by a truck! The world's largest single artwork, it took the artist and his team 15 days to complete. Between mammoth performance and ephemeral poetry, Denevan's works convey a bitter-sweet vision of man's place on Earth: capable of monumental feats, we must nevertheless bow to the forces of nature and the passage of time. Like haiku poems etched on the surface of the planet, these works can only be viewed in their totality from the air or in photographs, the only lasting proof that they ever existed. Far from the commercialisation of art and art salesrooms, Denevan produces works that are absolutely for free. This Californian artist divides his time between surfing, his art and the movement *Outstanding in the Field*, which he created. It advocates a return to nature and the origins of our food, organising huge outdoor dinners in different locations to honour the local farmers. Although a modest and retiring person, Jim Denevan does like to see things on a large scale, and his unbelievable works are fascinating.

Opposite and following double page:
***Untitled,* 2011,** various dimensions and materials, Half Moon Bay, California, United States

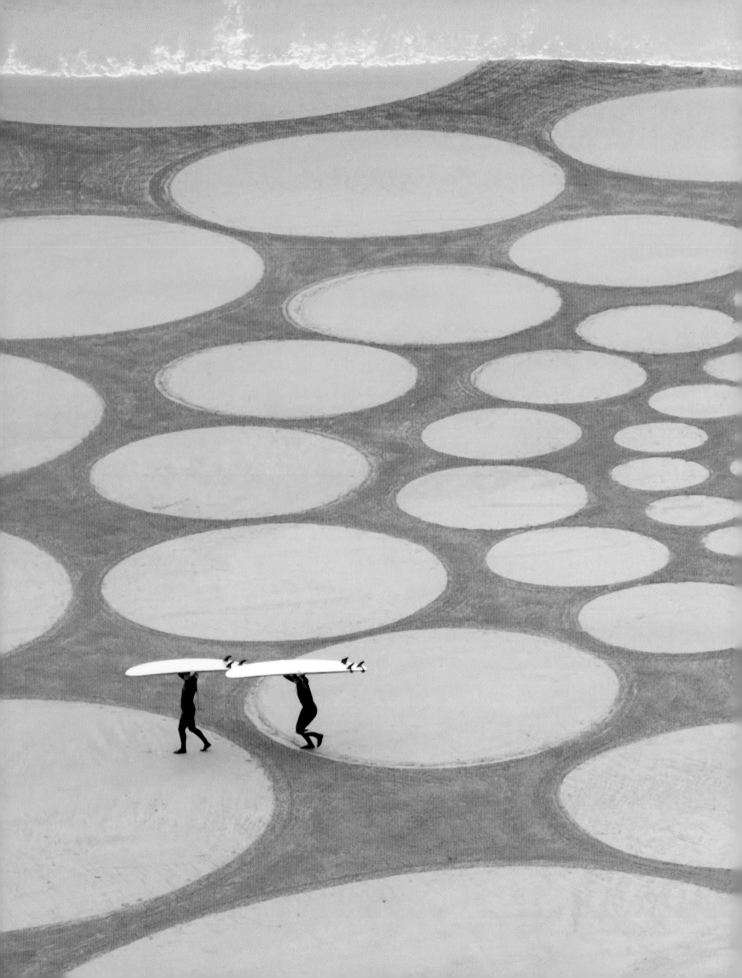

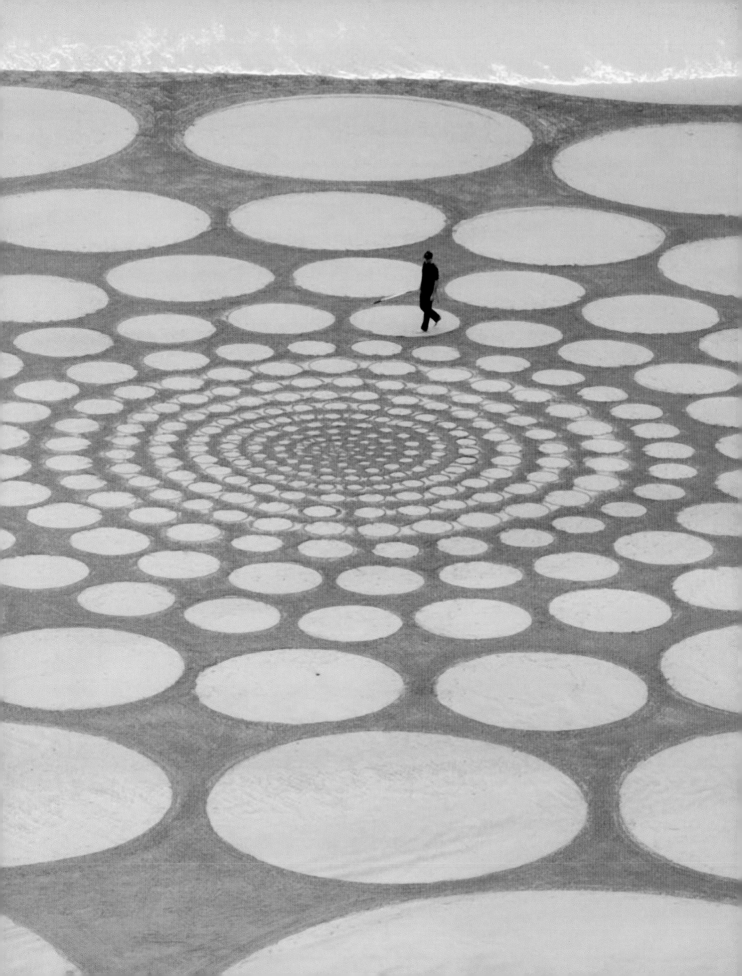

MEHMET
ALI UYSAL
(b. 1976)

Mehmet Ali Uysal focuses on the theme of space. The artist draws, during the creative process, inspiration for his work from the space that surrounds it. Whether the work of art is installed on a lawn or displayed on the walls of a museum, the artist plays with underlying structures, surroundings and context.

Mehmet Ali Uysal is a Turkish artist who studied architecture and sculpture. In 2010, at the "Festival of the Five Seasons" in Chaudfontaine, Belgium, he exhibited one of his best-known works, named *Skin 2*. A title which appears all the more mysterious when you see that this sculpture is a huge, six-metre-high clothes peg gripping a fold of grassy turf. It combines the bucolic and dreamlike with the aspect of a certain form of violence against our planet. The title "Skin" is a reference to the sensitivity of the earth, which suffers under our mistreatment. Amusing and intriguing, this work at the same time conveys an important message, using the very beauty of its surroundings to draw attention to their fragility. The artist shows respect for this environment by selecting natural materials for this sculpture, which is made mainly of wood. The representatives of the pop art movement before him exhibited oversized objects, but Mehmet Ali Uysal goes a step further by creating art *in situ* which is an inseparable part of the surrounding space. Transforming our perception of the landscape, this astonishing sculpture provides food for thought on subjects as varied as the place of a work of art in its surroundings, the link between art and nature and that between mankind and nature.

The works of Mehmet Ali Uysal are not always outdoor installations. The artist also likes to exhibit in indoor spaces, for example museums. Art becomes more than just the creation of the artist: the limitations of the exhibition space impose constraints on its realisation which in turn transform the space itself.

Skin 2, 2010,
6 × 10 × 15 m, wood, Chaudfontaine, Belgium

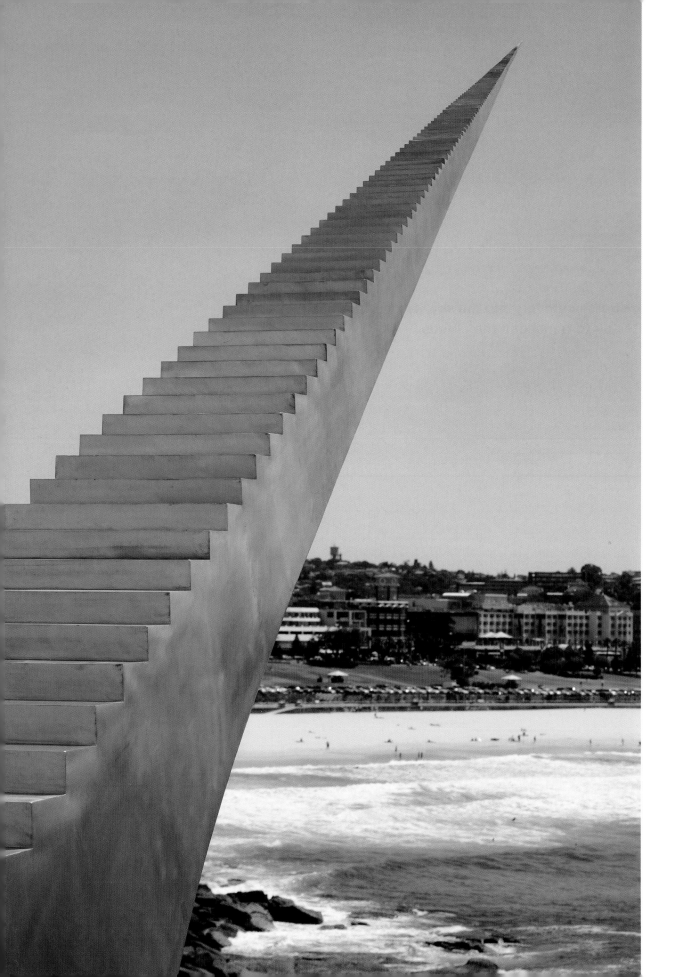

DAVID

McCRACKEN

(b. 1963)

The title *Diminish and Ascend* is a very down-to-earth description of an artwork that is anything but mundane. This sculpture by David McCracken is not merely a staircase that tapers as it seems to stretch infinitely into the sky; it is also a poetic vision that invites us to transcend the clouds.

David McCracken installed this surreal staircase for the seventeenth "Sculpture by the Sea" festival at Bondi Beach in 2003. It was an immediate success with spectators.

This New Zealand artist's fascination with sculpture began in adolescence. Before devoting himself full-time to art, he worked in boatyards and on building sites. With the skills he learned there, he began to create sculptures using a wide variety of media, ranging from construction materials to found objects. He likes the versatility of steel, but here, aluminium is his preferred metal. The smooth surface of the sculpture reflects the sky, reinforcing the illusion of a stairway to heaven. Made from simple, stripped metal, devoid of adornment, the sculpture owes its charm and aesthetic appeal to atmospheric nuances and its celestial destination.

Astonishingly, the sculpture is only nine metres long and about five metres in height; nevertheless, it seems to reach right up into the clouds. McCracken skilfully designed the steps so that they diminish in size the further up they are, which explains the name of the sculpture. This creates an optical illusion which, when weather conditions permit, gives the impression of an infinite staircase. On show for two weeks during the festival, the work is just perfect for the beach: the vast blue expanse of the nearby ocean reinforces the feeling of a surreal, magical staircase.

Diminish and Ascend, 2013,
5 × 9.5 m, aluminium, Bondi Beach, Sydney, Australia

ALEXANDER CALDER

ANISH KAPOOR

ARAM BARTHOLL

ARNE QUINZE

CÉSAR

CHRISTO AND JEANNE-CLAUDE

DANIEL BUREN

CONQUERING THE CITIES

DAVID ČERNÝ

FLORENTIJN HOFMAN

CAI GUO-QIANG

JEFF KOONS

JR

LOUISE BOURGEOIS

MAURIZIO CATTELAN

OSGEMEOS

For a long time, the Western world extolled the virtues of the countryside, vehemently denying that there was any beauty or poetry to be found in cities. But the Industrial Revolution in the 19th century, with the resulting faith in progress and a certain admiration for urban settings led to their positive portrayal in art. And what is the situation today? Although we may marvel at the sight of a city, find beauty and aesthetic quality in urban surroundings, for many people, cities are still synonymous with pollution, stress and an all-pervading bleakness that even casts its grey shadow on the morose expressions of the inhabitants. So some artists set themselves the task of brightening the lives of the urban population with artworks that break the monotony with dashes of bright colour and pleasing shapes. The bright red bird-flower by Alexander Calder (see pages 56–57) or the red-orange sculptures by Arne Quinze (see pages 78–81) are just two examples. These are works that challenge the surrounding buildings and structures by means of their colossal dimensions. An urban setting also guarantees maximum visibility for an artwork: it is installed in a busy location and can be admired free of charge. This gives the artist the chance to introduce art to people who would probably never visit a museum or art gallery. The museums themselves have recognised the importance of making art accessible and conspicuous, and have increasingly begun to display works outdoors, for example, in front of the entrance. Jeff Koons' flower-covered puppy, which stands in front of the Guggenheim in Bilbao (see pages 68–69), was originally intended to be a temporary exhibit, but remained in place by popular demand; an impressive demonstration of the impact of art on the public. And some years ago, a new urban art form

was born: street art. This movement, originating in the poorer areas of cities, has convinced experts and the public alike. In addition to the aesthetic aim of brightening up the concrete, street art often has social or political ambitions. Nowadays, street artists have the means to create works on a gigantic scale, such as those of OSGEMEOS (see pages 86–87) or JR (see pages 88–93). Commissioned by museums or town halls or installed illegally by their creators, these works can be found in towns and cities throughout the world, on the streets, on subway walls, in town squares or on buildings. The perfect way to introduce the general public to art!

Pages 52–53:
Maurizio Cattelan (see pages 110–111)
L.O.V.E, **2011,**
4.7 × 2.2 × 7.2 m, marble, Piazza degli Affari, Milan, Italy

Pages 54–55:
Anish Kapoor (see pages 158–161)
Cloud Gate, **2006,**
10 × 20 × 13 m, stainless steel, Millennium Park, Chicago, United States

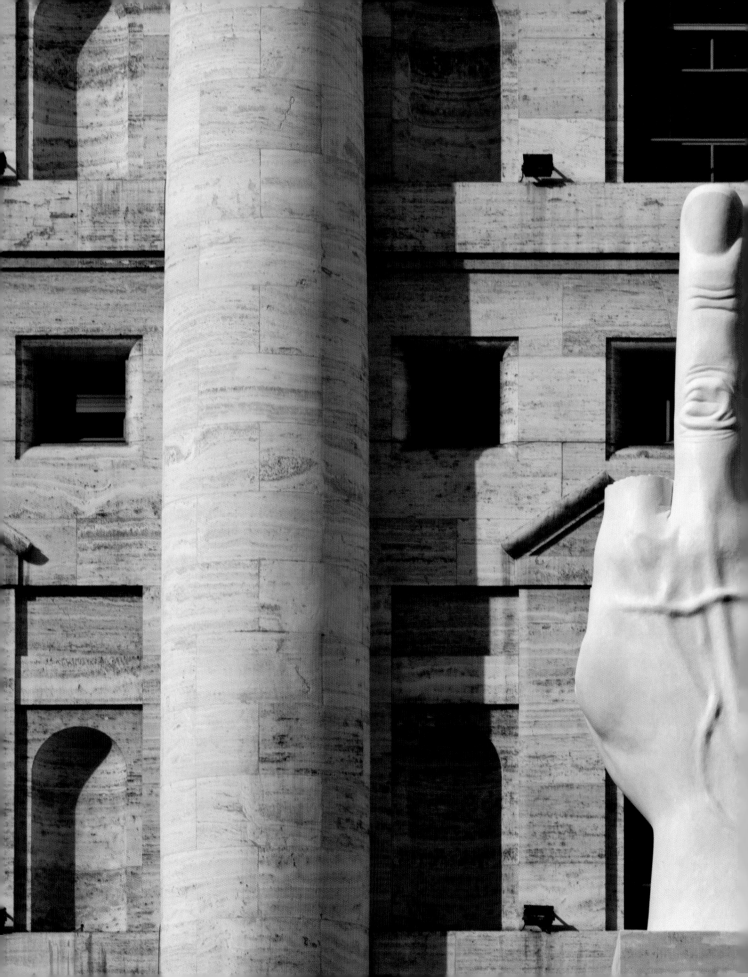

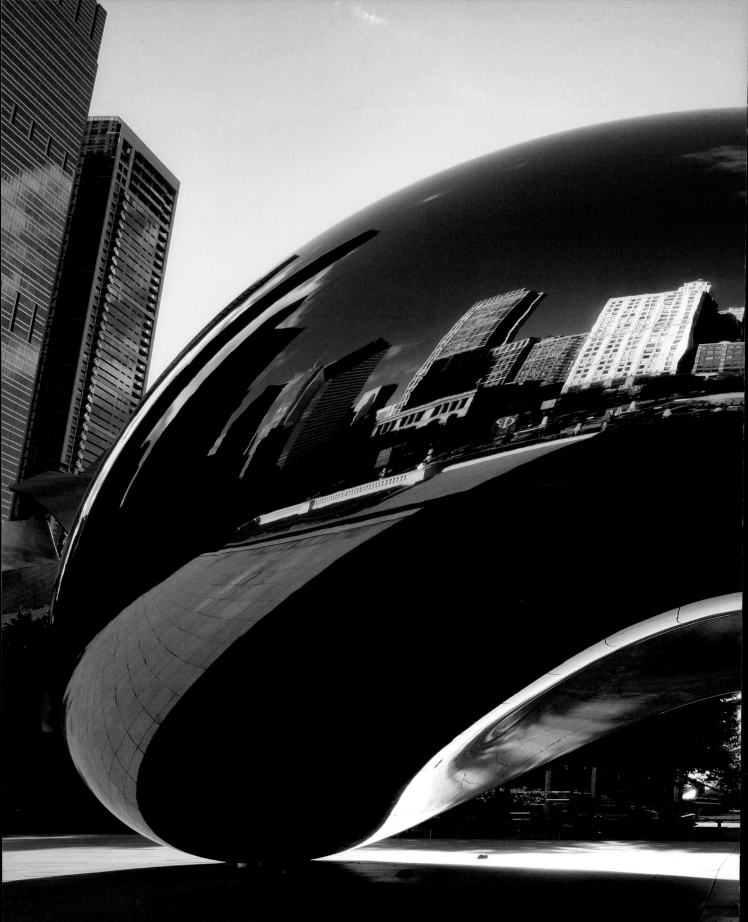

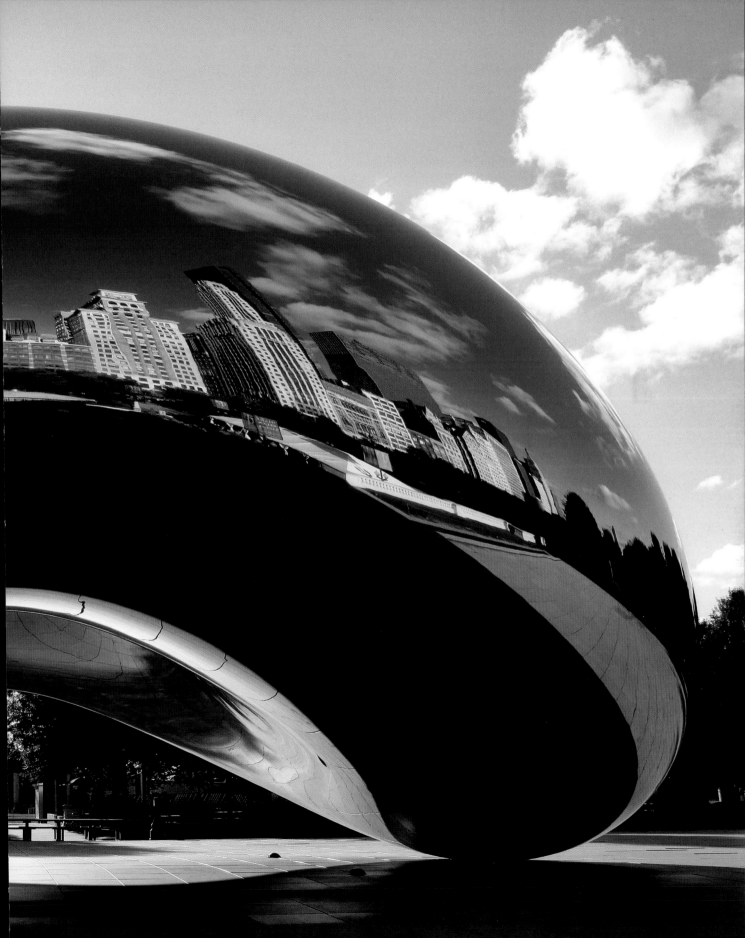

ALEXANDER CALDER

(1898–1976)

Alexander Calder created *Flamingo* in 1973. It is an abstract structure which, despite the name, can just as easily be seen as representing a leaning flower or an insect as a bird. The vermilion aerial steel touches the ground at five points, allowing passers-by to walk underneath its curves, and the colour contrasts attractively with the sombre and symmetrical office buildings of Chicago's Federal Center Plaza.

Calder was born into a family of artists, several of them sculptors. Before following in their footsteps, he first studied mechanical engineering and became an engineer. This training was useful to him in his later career as an artist, in particular when building his famous "mobiles," kinetic sculptures with ingenious mechanisms which allowed them to move. A handyman and jack-of-all-trades, he lived in France for many years, where he became part of "Abstraction-Création," a group of artists who advocated a formal art style devoid of figurative references. The terms "mobile" and "stabile" applied to his works are French terms, although Calder was American; they were invented by Marcel Duchamp and Jean Arp respectively, both fellow artists. *Flamingo*, unlike the majority of Calder's art, is a stabile, that is to say, it is completely stationary. This amusing vermilion bird measures 16 metres in height. Calder collaborated with steel-working companies to produce sculptures on this scale, providing them with a scaled-down model and supervising the final construction. Replicas no larger than two metres were used to verify the stability of his planned projects. By the time *Flamingo* was unveiled in Chicago, Calder was already world-famous. On the same day, a mobile, *L'Univers*, was inaugurated in the neighbouring Sears Tower and an exhibition, "Alexander Calder: A Retrospective," opened in Chicago's Museum of Contemporary Art. The city proclaimed 25 October 1974 "Alexander Calder Day" and organised a circus parade, the circus being a theme that often featured in his work.

Flamingo, 1974,
height: 16 m, steel, Federal Center Plaza, Chicago, United States

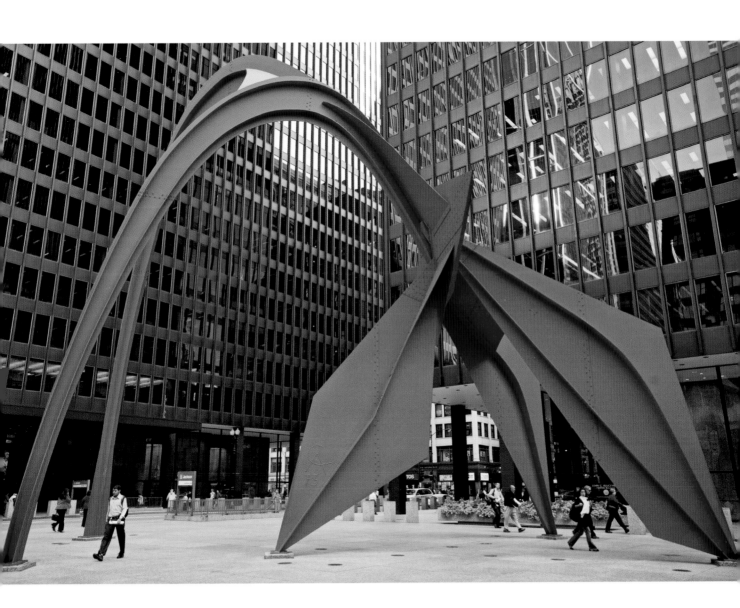

LOUISE
BOURGEOIS

(1911–2010)

Louise Bourgeois' career spanned almost eight decades. The artist expressed herself through the media of painting, drawing, performance, engraving… She was associated with many of the major movements of the 20th century, for example surrealism, minimalism, abstract expressionism and feminism. Like her sculpture *Maman*, many of her disturbing works were inspired by the trauma of her youth.

Louise Bourgeois received the commission for *Maman* in 1999. The work was part of the Unilever Series and was exhibited for the first time in the Tate Modern's Turbine Hall in London. The spider was not a new image for the artist: it appeared for the first time in a series of drawings she created in the early 1940s and assumed a more central role in her work starting in the 1990s. On one drawing, Louise Bourgeois wrote a note which explains what the spider symbolised for her: "The friend […] (the spider—why the spider?) because my best friend was my mother and she was deliberate, clever, patient, soothing, reasonable, dainty, subtle, indispensable, neat, and as useful as a spider. She could also defend herself."

Louise Bourgeois' mother was a weaver, another feature she had in common with the spider, which spins its thread web. She died when her daughter was only 21 years old. In despair, Louise threw herself into the river Bièvre, from which she was rescued by her father. As an artist, she chooses to ignore the frightening aspect of the spider. The dark colouring of the steel of which *Maman* is made, its sharp-tipped legs and above all its size—the sculpture is almost 10 metres high—may appear ominous, until a closer look reveals that the spider's legs are in fact graceful and fragile and that it has a sac full of marble eggs suspended from its abdomen. The spider is a mother, but also a predatory female (certain species kill the male after mating), both fragile and menacing; it can have many connotations. In any event, the fascination it holds for the public can be measured by the popularity of the work with audiences. Several versions have featured in exhibitions all over the world, for example in Saint Petersburg, Tokyo, Copenhagen, Denver, Kansas City, San Francisco, New York, London and Paris.

Maman, 2007,
9.3 × 8.9 × 10.2 m, bronze, stainless steel and marble, Guggenheim, Bilbao, Spain

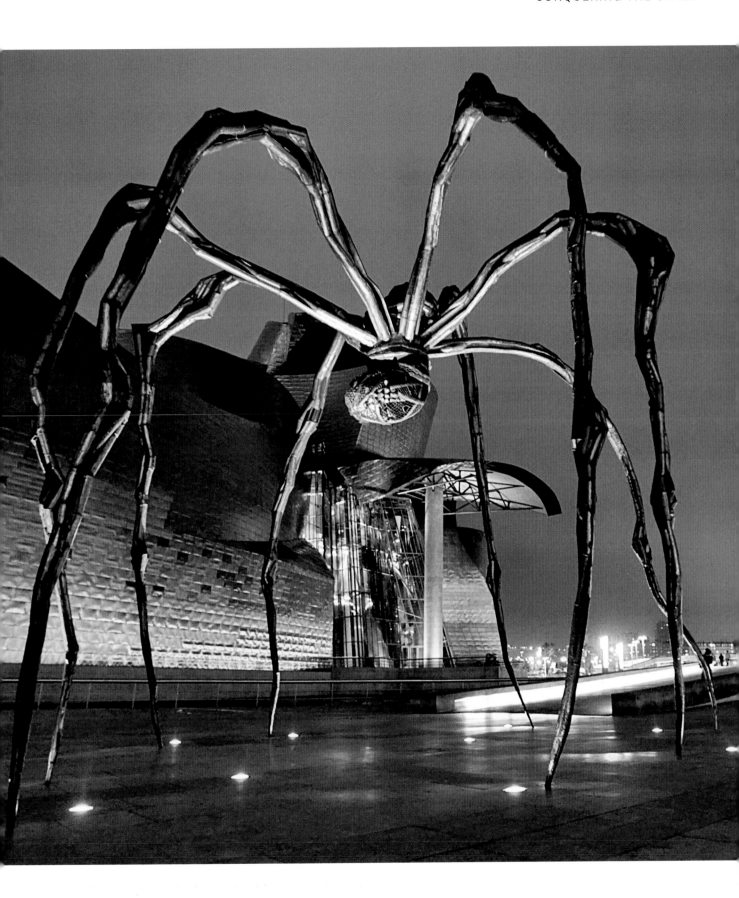

CÉSAR

(1921–1998)

La Défense, the financial district of Paris, has a somewhat dehumanised air: a wide boulevard full of hurrying office workers and sleek, shining, futuristic buildings… This is the location of *Le Pouce* (French for thumb), a work by one of France's best-known sculptors: César. Based on a cast of the artist's hand enlarged to a height of 12 metres, this anatomical fragment adds a little humanity, a note of absurdity, to this otherwise all-too sober and businesslike location.

César created the first *Pouce* in 1965 for an exhibition on the subject of the hand at the Claude Bernard gallery in Paris. Made of pink plastic, it measured only forty centimetres, far smaller than the one in La Défense. But César did not stop there: he created a whole series of imprints of human body parts (hands, fists, breasts) and increasingly large thumbs in various materials. The ones that attracted most media attention were one commissioned for the Olympic Games in Seoul in 1988 (six metres high) and the sculpture in la Défense, both in bronze. The artist owes his passion for enlargement to his discovery of the pantograph, an instrument with which the scale of his sculptures could be enlarged. This device fired his imagination in much the same way as the scrap press which allowed him to create works of art made from several compressed scrap cars, producing perfect rectangles inside which the viewer can distinguish the crushed vehicles and which he exhibited just as they emerged from the press. The pantograph produces enlarged duplicates in different sizes. Nevertheless, César's reproductions of the *Pouce* are not copies; each is a distinct work of art. It is true that through its gigantic proportions, the sculpture in La Défense presents us with a new and original view of the human thumb. To those who claimed that a cast was not a work of art, César replied: "Even if it is the case that there is nothing more anti-sculpture than a human imprint, I do believe that in developing my imprint to the scale that I do, I transform it into sculpture."

Le Pouce, 1994,
height: 12 m, bronze, La Défense, Puteaux, France

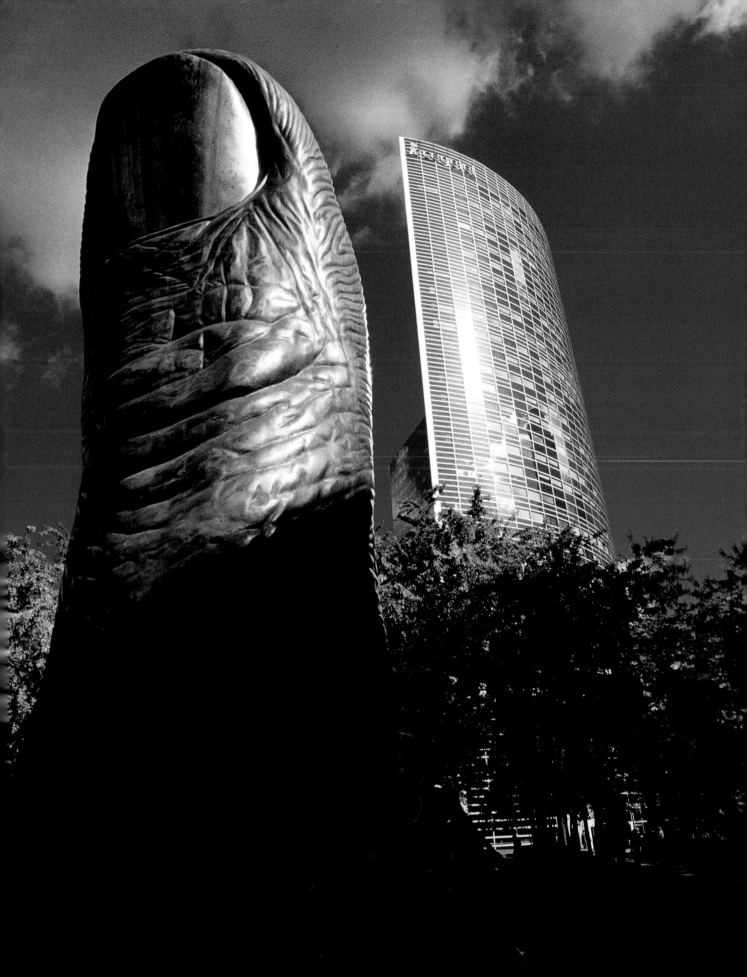

CHRISTO & JEANNE-CLAUDE

(b. 1935 and 1935–2009)

"100,000 m² of fabric," "more than 600 persons involved in its installation," "25 years of work"… As crazy as it may seem, these daunting figures refer to works of art! More precisely, they refer to the work of Christo and Jeanne-Claude. And while the gigantic dimensions of these projects amaze, what is most stupefying is their duration—they remain in place for just a few brief days…

Though born "during the same hour and on the same day," Christo and Jeanne-Claude met by chance and much later, in Paris in 1958. They quickly developed a passion for wrapping things. Very soon, they had set their sights on larger targets, much larger, and were involved in wrapping objects of truly gigantic dimensions: trees, bridges, monuments, islands, even kilometre-long stretches of the Australian coastline. The bigger the challenge, the more the two artists… got wrapped up in it! The spectators did, too, as every one of these brief-lived installations drew crowds of curious onlookers, for example in Berlin in 1995. Over a period of two weeks, five million people came to see the Reichstag building enveloped in 100,000 m² of polypropylene.

In 2005, before the death of Jeanne-Claude, the couple completed one last project, on which they had been working for more than 25 years: *The Gates*. Without a doubt, it is their most impressive work: they obtained permission from the Mayor of New York to install 7,503 gates topped with saffron-coloured fabric along the paths of Central Park, creating one huge luminous pathway.

Today, Christo continues their work alone, hoping to complete at least two projects he has been working on for years. He dreams of swathing the Arkansas river in Colorado in a "coat" of 10 kilometres in length, but also of installing his first monumental permanent work, near Abu Dhabi: a sculpture of a mastaba (flat-roofed tomb), 150 metres high. It would be the largest sculpture in the world.

The Gates, 2005,
7503 porticos, 37 km course, approximate height of each gate: 5 m,
vinyl with steel bases, Central Park, New York, United States

Following double page:
Wrapped Reichstag, 1995,
approximate height: 75 m, polypropylene, aluminum, blue rope, Berlin, Germany

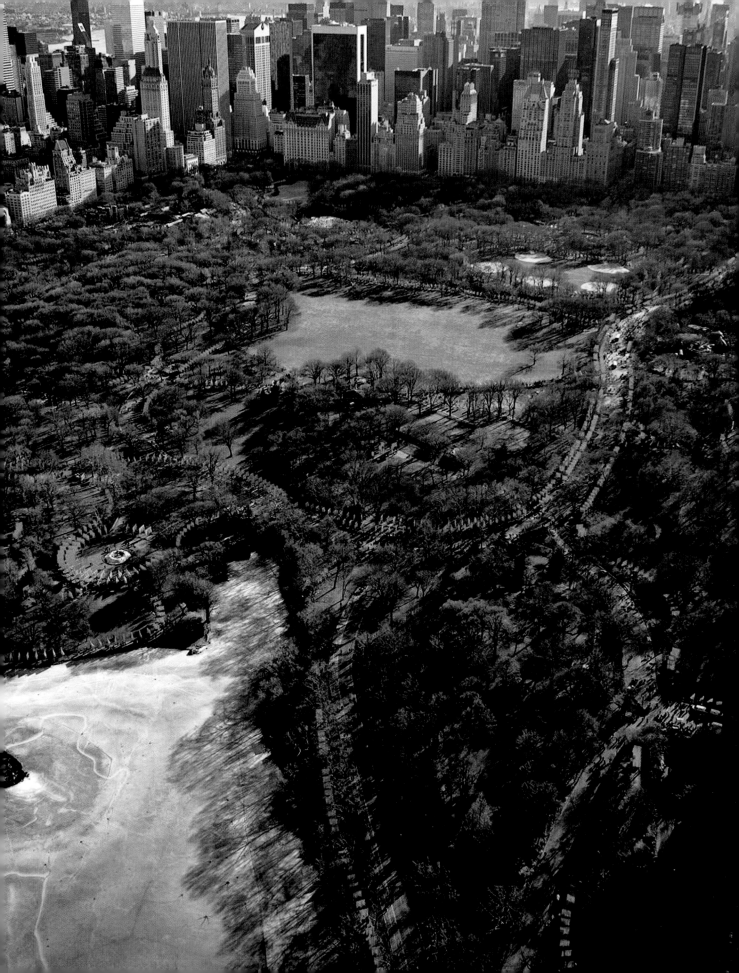

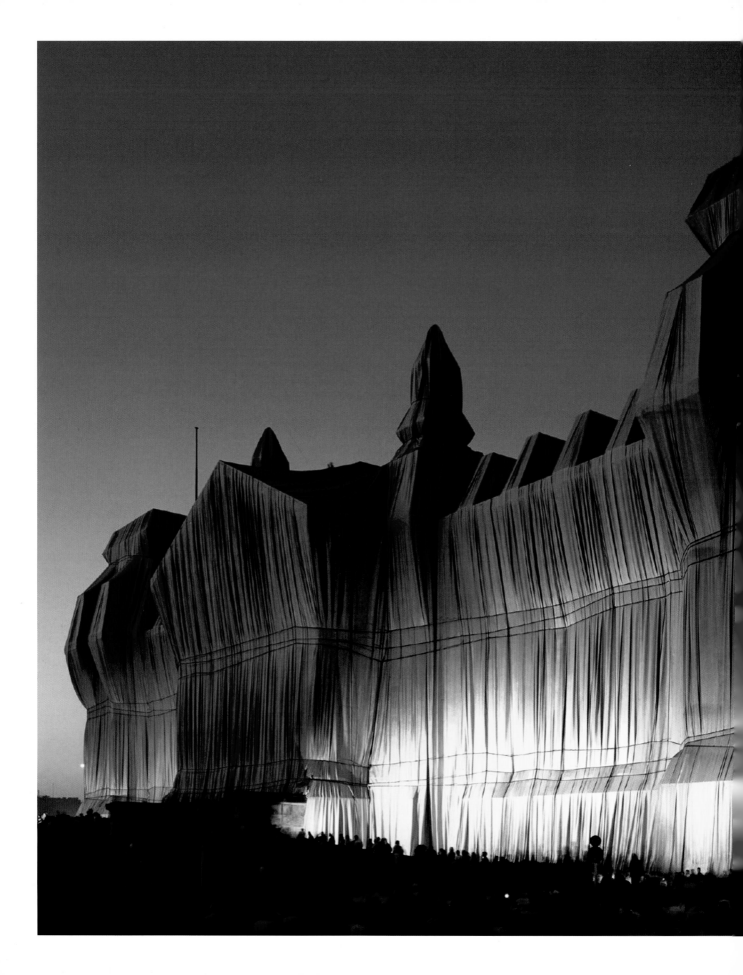

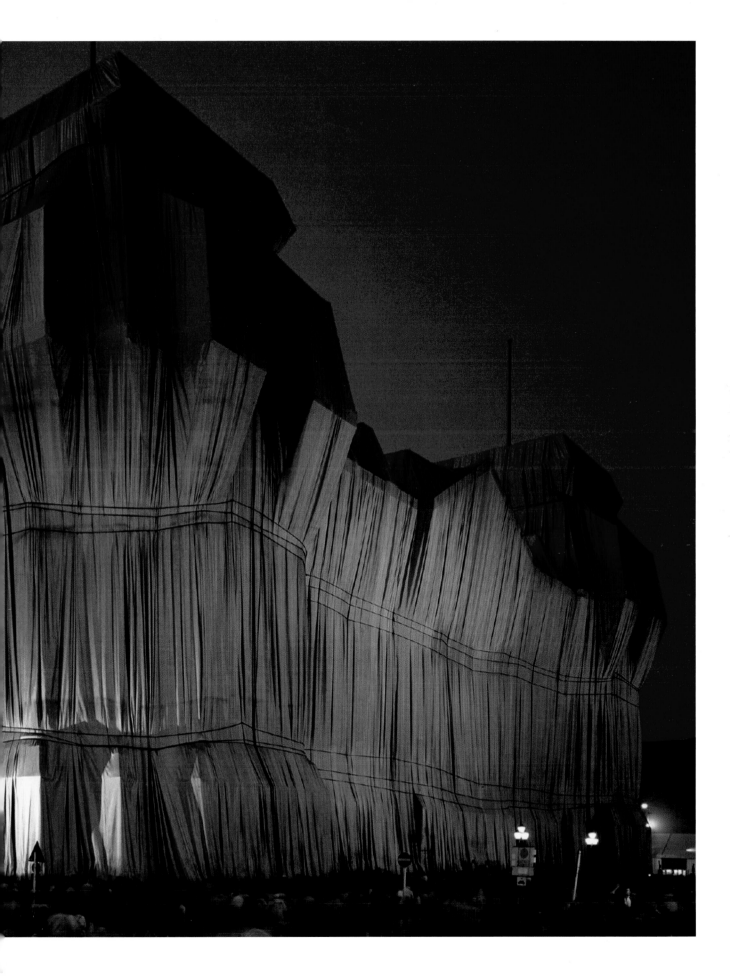

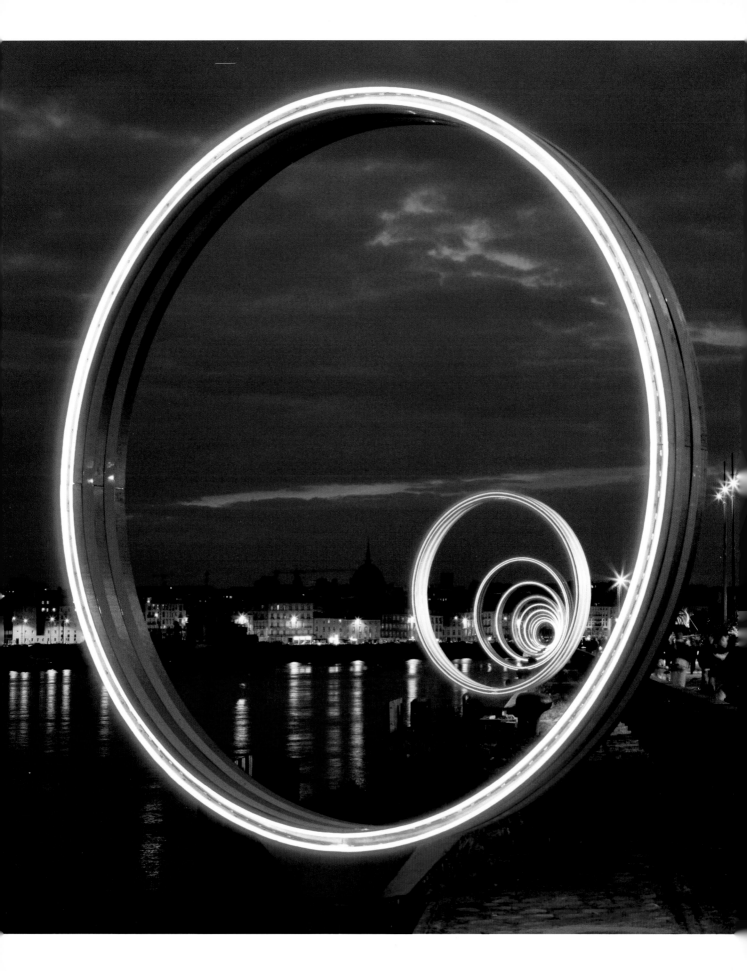

DANIEL
BUREN
(b. 1938)

Daniel Buren is world-famous, principally for the trademark black and white stripes, 8.7 cm wide, which he calls his "seeing tool." He discovered this motif in 1965 and has used it in his work ever since. Lacking funds at the beginning of his career and unable to afford a workshop, he worked *in situ*, a habit he has maintained throughout his career, seeking to associate his installations with the space in which they are presented.

Following the Anish Kapoor exhibition in 2011 (see page 158), the Monumenta project showcased Buren in 2012 (each year an artist of international stature is invited to install a work in the nave of the Grand Palais in Paris). Fascinated by the spaciousness of the building and the light streaming through its domed glass roof, the artist, in collaboration with architect Patrick Bouchain, created discs of coloured plexiglass supported by poles with the vertical black and white stripes which are his recurring motif. The two men took their inspiration from a 10th-century Arabian pattern. Its ingenuity allowed them to construct circles of five different sizes, touching each other and separated by triangular spaces which all had the same dimensions. Visitors to the exhibition therefore passed through patches of different-coloured light: the coloured light of the transparent discs and the natural light of the empty triangles. Mirrors were mounted at floor level in the centre of the installation, reflecting the colourful discs and the nave. Large square blue panels were attached to the glass of the roof, amplifying the play on light.

The artist also realised another work with Patrick Bouchain, this time a permanent installation in Nantes, France. *Les Anneaux* (The Rings) consists of 18 circles of striped metal, silver and white by day and illuminated in different colours by night. It was 18 boat mooring rings which immediately inspired Buren to install his rings at equal distances from each other. Of the same dimensions and all facing the same way, they frame the spectator's view through them. At night, they create a luminous ensemble that varies according to where you stand. As to their meaning, the artist's lips are sealed. He prefers to leave the beholder free to interpret the work as he sees fit. In fact, Buren admits that various comments made by the public have led him to discover new dimensions in his own work.

Photo-souvenir: Les Anneaux, 2007,
4 m in diameter, flexible metal, LEDs, Nantes, France

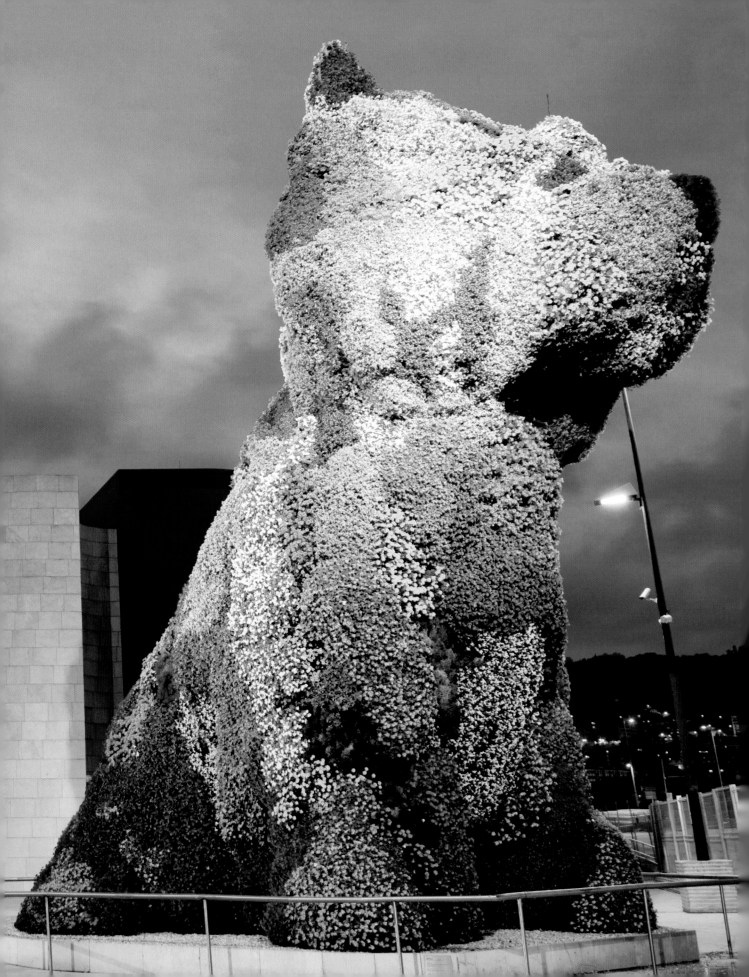

JEFF
KOONS
(b. 1955)

Former golden boy of Wall Street, Jeff Koons has been an internationally acclaimed artist since the 1980s. Taking his inspiration from the imagery of advertising and taking a mocking look at consumer society, he chooses to use banal objects exhibited just as they are (like the vacuum cleaner *Hoover*) or turn elements of popular culture into works of art (for example *Bubbles*, a porcelain sculpture of Michael Jackson and his chimpanzee). This grand master of kitsch, in many ways following in the footsteps of Andy Warhol, directs a workshop in which his ideas are converted into artworks by a whole team of assistants.

Koons successfully blurs the boundaries between popular and high art. His works are sold for fabulous sums and exhibited in major museums all over the world. He aims to reach as many people as possible with themes and symbols from the popular consciousness. He says he intended *Puppy* to instil a feeling of "confidence and security." Reminiscent of the formal gardens of the 18th century, this topiary sculpture was above all inspired by images with popular appeal: puppies and flowers. Despite its size—the steel structure is more than 12 metres high—the puppy has a harmless look, which is how Jeff Koons intended it. He offers an interpretation of this gentle giant: "I think *Puppy* has a lot to do with fertility and with life. And with power. You can have a puppy, lavish a lot of love on it, take care of it, but you can also keep a puppy to fetch the newspaper for you. […] This is the case with *Puppy*, where the tension involved in the exercise of power is diminished." The work is impressive in its design: a steel structure over 12 metres in height is covered with earth and plants that are watered automatically and replaced once a year. Created for a temporary exhibition in Germany, *Puppy* went on tour before being installed permanently, by public demand, in front of the Guggenheim in Bilbao.

Puppy, 1992,
12.4 × 9.1 × 8.3 m, stainless steel, soil and flowering plants, Guggenheim Bilbao, Spain

CAI
GUO-QIANG
(b. 1957)

Artist Cai Guo-Qiang is a master of the spectacular: drawings, installations or performance art, the majority of his works are on a large scale. Defying artistic conventions, this explosive plastic artist uses a very unconventional material for his ephemeral creations: gunpowder.

Cai Guo-Qiang experimented with the potential of gunpowder as an artistic material very early on in his career. He started by using it to draw: once the powder is distributed on the paper, all you have to do is set light to it in order to fix the drawing on the sheet. Later, Cai staged real explosions in outdoor locations and even organised pyrotechnic events. He was, for example, in charge of the fireworks displays at the opening and closing ceremonies for the Olympic Games in Beijing in 2008. The artist uses these explosive events to create a special link between the viewers and the universe around them, because it is his belief that explosion and fireworks unleash a unifying energy. Although Cai Guo-Qiang left China in 1986, moving first to Japan and then to the United States, Chinese culture has remained a major influence in his work: it contains references to traditional Chinese medicine and feng shui — a discipline which aims to balance energies and energy flows — and in particular to the mythology and history of China as well as its aesthetic, religious and philosophical tradition.

In 2009, Cai received a commission for a work in homage to a former director of the Philadelphia Museum of Art, the late Anne d'Harnoncourt. He created *Fallen Blossoms*, a transitory work, lasting just 60 seconds, in which a blossom of fire unfolds and fades. The title refers to a Chinese proverb evoking the deep feeling of solitude following a sudden death.

Cai also works without explosives, creating lasting works such as *Head On* (see pages 98–99), a stunning installation showing a pack of 99 wolves launching themselves… straight into a wall of glass! Originally created for the Guggenheim Museum in Berlin, the work represents present day tensions between the former East and West Germany. The life-size replica wolves, made from cables, painted sheepskin, plastic and marble, shows a society whose inhabitants blindly follow the decisions of the collective, even if they are absurd.

Fallen Blossoms: Explosion Project, **2009,**
approximate dimensions of the explosion: 18.3 × 26.1 m, fuses, detonator, wire mesh, scaffolding,
60-second explosion event, Philadelphia Museum of Art, Philadelphia, United States

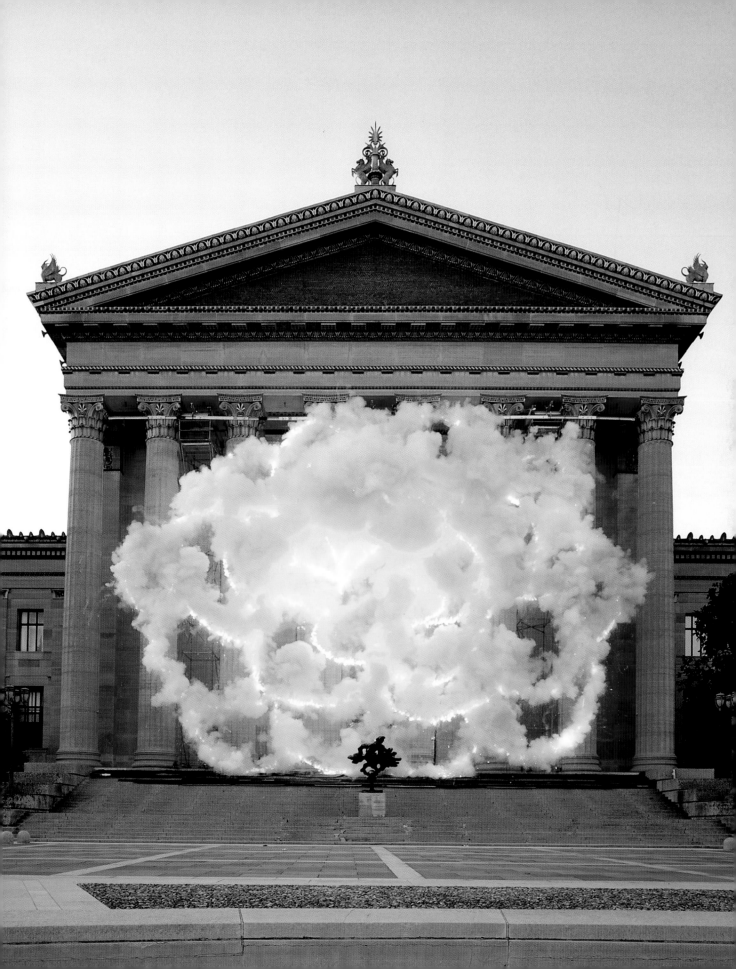

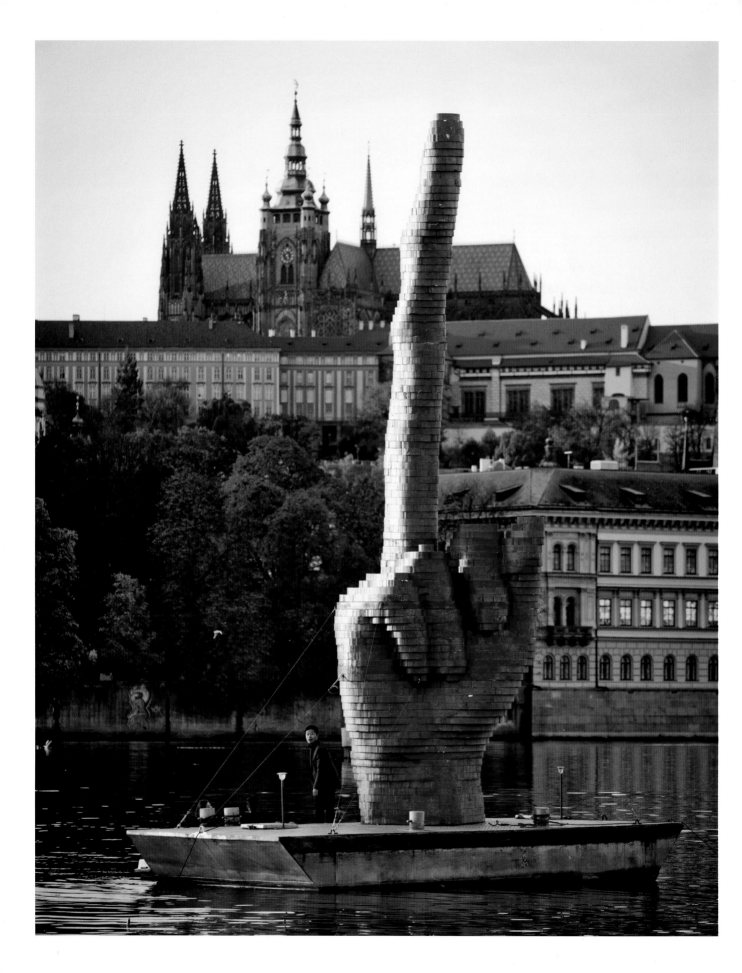

DAVID ČERNÝ
(b. 1967)

The message is clear: this hand with its extended middle finger, floating on the river Vltava in the Czech capital, is both a political and an artistic statement. David Černý, who created *Gesture*, is well-known for his anti-Communist stance. The sculpture was installed opposite Prague Castle, the seat of President Milos Zeman, shortly before the parliamentary elections.

An artist who is no stranger to scandal, Černý began his career by painting a Soviet tank commemorating the liberation of Prague by the Red Army pink. A student prank? More than that: the act has a political meaning. The tank, viewed as a symbol of the Soviet threat by the majority of the population, is ridiculed, rendered impotent by the pink paint that makes a mockery of its warlike function. And the Russians certainly understood the message; an official complaint was sent to the Czech government. Černý was arrested, although he was released soon afterwards in response to an outcry from members of parliament, but he refused to be quieted. More than 20 years later, he is still protesting, in this case with the help of a 10-metre-high extended middle finger. His protest is directed at the Czech President, a former member of the Communist party, with which he proposes to enter into an alliance; for the first time since the anti-Communist Velvet Revolution of 1989, the Communists seem about to renew their ties to power. Yet, many Czechs, among them Černý, still associate Communism with 41 years of oppression. Apart from the information that the colour purple was chosen because it did not stand for any political party, Černý offers no explanation of his work, claiming that it speaks for itself. It is certainly very effective in terms of communication: newspapers all over the world are talking about *Gesture*. The location of the sculpture is also well-chosen; it is installed not far from Charles Bridge, a popular tourist attraction.

Gesture, 2013,
height: 10 m, Vltava river, Prague, Czech Republic

FLORENTIJN HOFMAN

(b. 1977)

Florentijn Hofman's career began in the early years of the new millennium with giant works of art inspired by children's toys. The public installations of this artist from the Netherlands, entertaining and effective, convey simple messages everyone can identify with.

This is a duck with a world-wide reputation: it has already attracted crowds in cities as far apart as Kaohsiung (Taiwan), Pittsburgh (United States), Baku (Azerbaijan) or Auckland (New Zealand). With its gigantic dimensions and bright yellow colour, it's just impossible to miss. Contrary to popular belief, however, there is not one single *Rubber Duck* but several sailing the waters of our planet. The original version, invented in 2007 for the contemporary art festival "Estuaire," was 26 metres high and was to go on display at various points along the Loire estuary. However, the project was cancelled as it was too difficult to realise due to its enormous size. And so further versions of *Rubber Duck* were created (a new one for every location), varying in height from 5 to 14 metres. This friendly duck, capable of "relieving global tension," candidly evokes joy, love and peace. Nevertheless, it has suffered several setbacks: after deflating miserably at Saint Nazaire in 2007 and in Hong Kong in 2013, it promptly exploded in the port of Keelung in Taiwan on 31 December 2013, just a few hours before the start of the new year. An eagle—perhaps jealous of the success of its inflatable 'brother'—is said to have launched a cowardly attack on it.

" RUBBER DUCK TELLS YOU NOT TO WORRY, TO SMILE AND BE HAPPY. "

Created with the same infectious humour, *Macaco Gordo* ("Fat Monkey") was installed in São Paulo in 2010, within the framework of the "Pixel Show," a conference on art, design and creativity. Made from 10,000 colourful plastic flip-flops attached to an inflatable structure, this enormous primate was made on-site with the help of local teams. Florentijn Hofman always realises his art installations in this way, as he believes that these public works of art should belong completely to the inhabitants of the place where they are exhibited.

Rubber Duck, 2013,
13 × 14 × 15 m, inflatable structure, pontoon and generator, Sydney, Australia

Following double page:
Macaco Gordo (Fat Monkey), 2010,
5 × 4 × 15 m, inflatable structure and flip-flops, São Paulo, Brazil

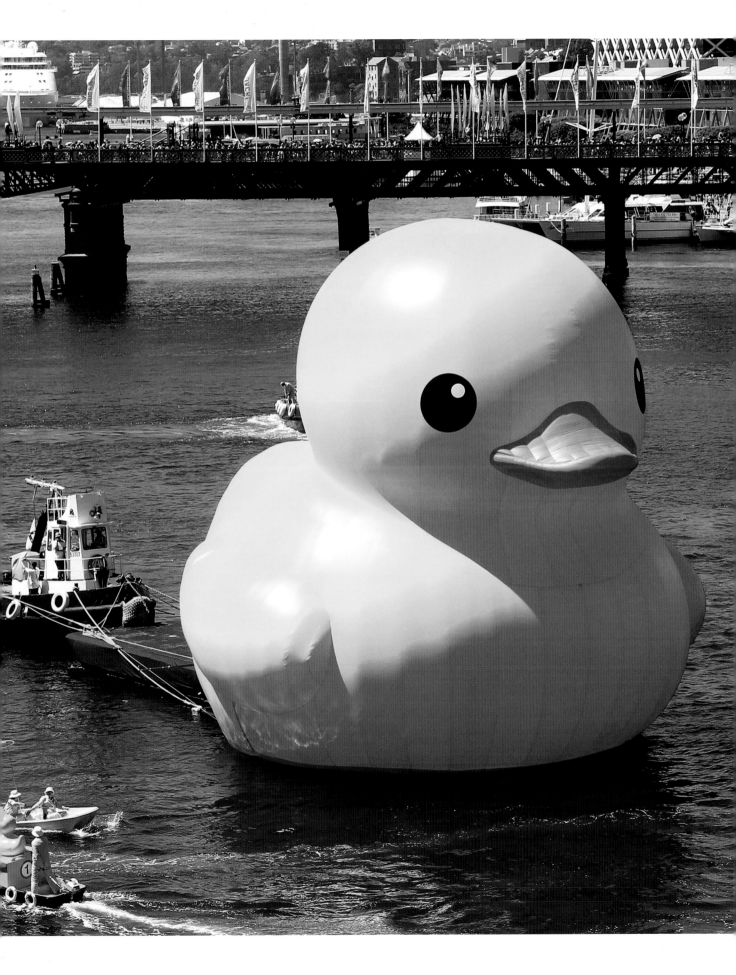

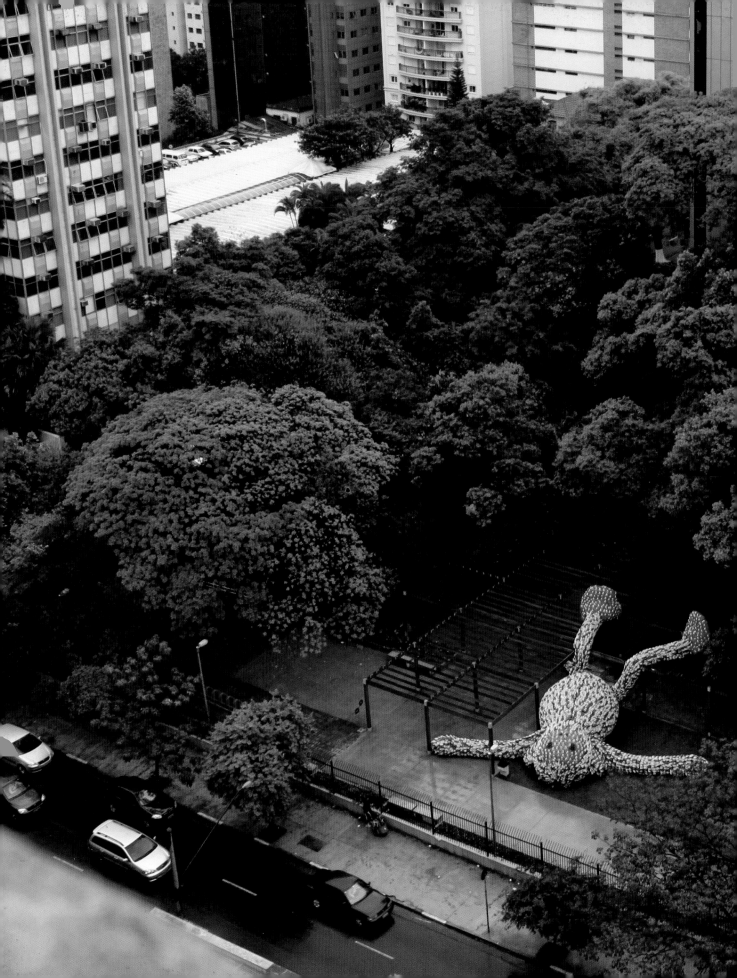

ARNE QUINZE

(b. 1971)

Belgian Arne Quinze, who never completed formal art eduction, began his career as a graffiti artist, but soon began to make the large-scale installations with which he aims to change the interaction between man and the urban environment. He believes art is a fundamental power than can exert a positive influence on man and the urban environment.

Quinze became famous when he built a huge wooden sculpture for the Burning Man festival in Nevada (United States). It was 30 metres high, and, following the tradition, the effigy was burnt at the close of the event. He has a predilection for structures made from wooden slats arranged in apparent chaos such as *The Visitor*. This work, installed in Beirut, is part of the artist's *Stilthouses* series, wooden structures on stilts which the artist perceives as very like human beings. Like man, they seem fragile on their frail "legs," looking as if they might collapse any minute; yet they are robust, and their flexibility and their equilibrium reveal their strength. Like man, they can adapt to any context. The artist was frequently asked to explain his choice of a vibrant orange-red for *The Visitor*. It is, he explains, "the most human colour there is. It is full of contradictions, just as we are." It is the colour of the flames that can warm or burn us,

" WITH MY MONUMENTAL SCULPTURES, I SEEK CONFRONTATION WITH MY AUDIENCE. "

of blood which symbolises life but also death … It is also a striking contrast, adding a welcome touch of colour to our predominantly grey cityscapes. Quinze frequently uses this orange-red, which is also the colour of his *Rock Strangers*. These unusual structures are installed on the sea-front of Ostend, with the aim, as always, of changing the urban environment. He has extended the "Rock Strangers" series with installations in other cities, some real, others virtual, for example with the smartphone app for Beck's Green Box Project, which enabled the user to see *Rock Strangers* superimposed on digital images of famous monuments. Another novel way of transforming our cities and bringing a smile to people's faces.

The Visitor, 2009,
wood, polyurethane, paint, Beirut, Lebanon

Following double page:
Rock Strangers, 2012, 10 m in diameter, metal, Ostend, Belgium

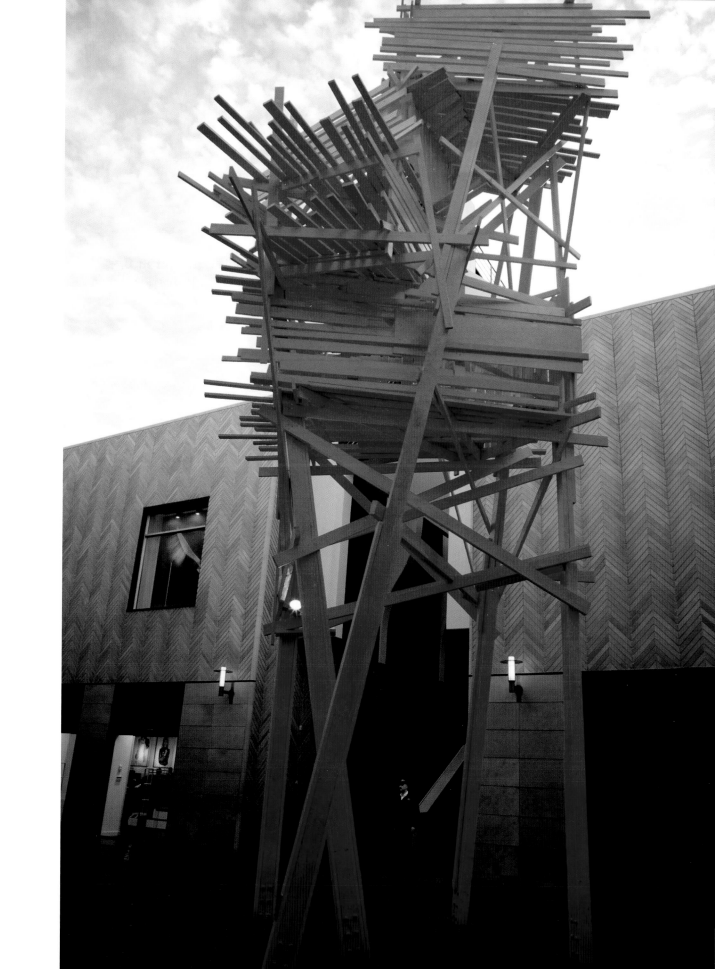

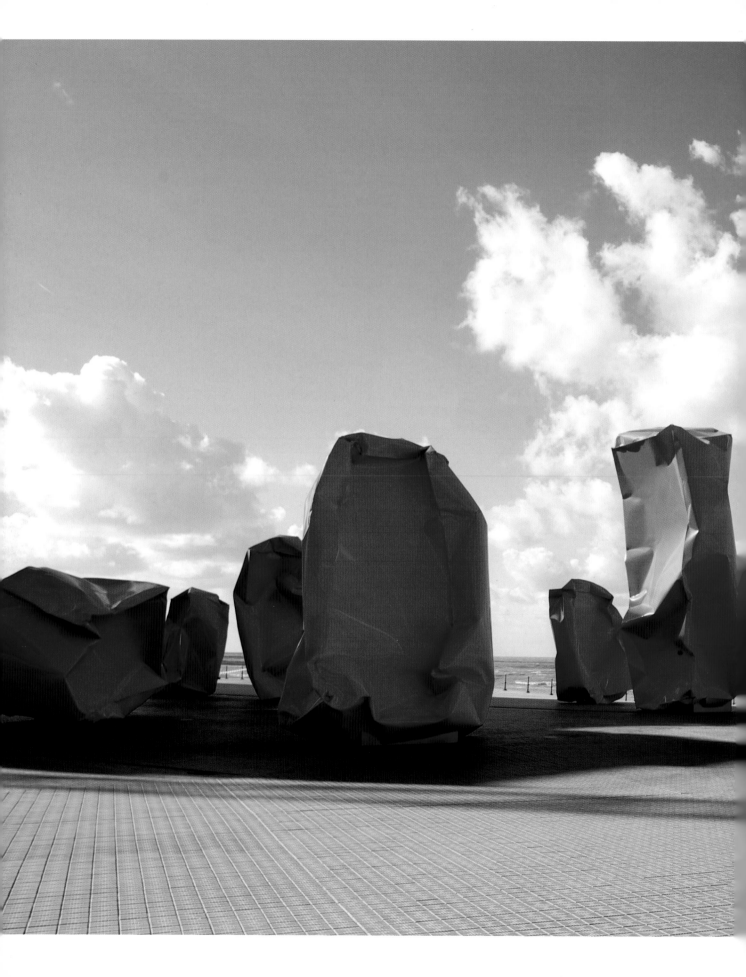

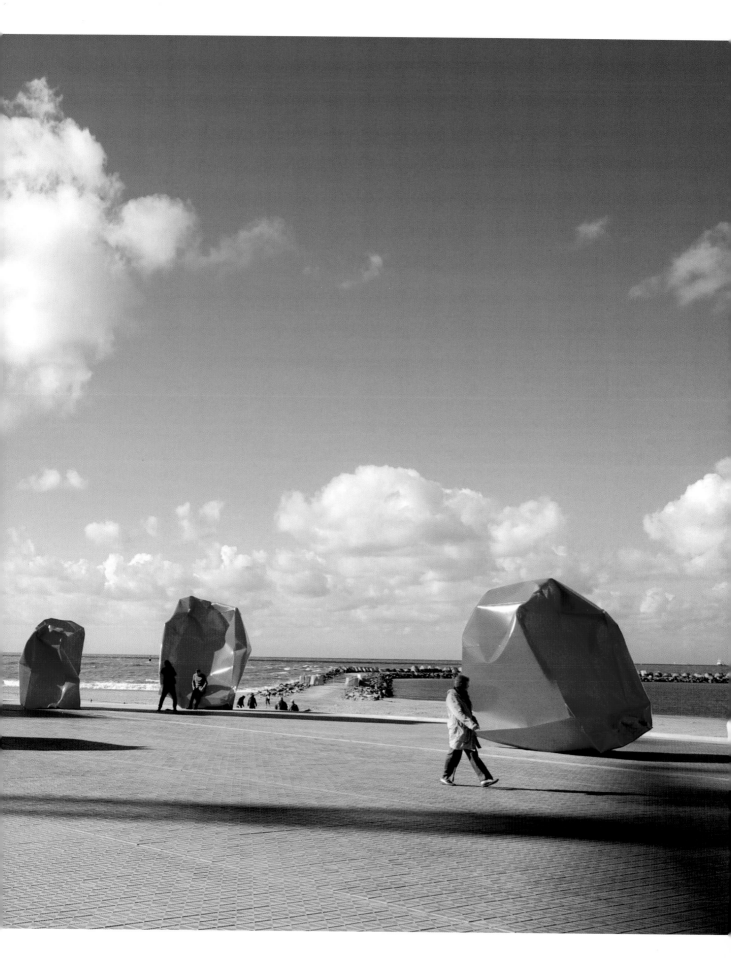

ARAM
BARTHOLL

(b. 1972)

The Internet is omnipresent in our lives: checking our e-mails, finding out what the weather will be like and catching up with the latest news with one mouse-click have become run-of-the-mill tasks we perform every day. Aram Bartholl's works transpose virtual phenomena into real life, ironically questioning our sometimes almost slave-like dependence on the Internet.

Bartholl works in Berlin and is fascinated by the relationship between the digital and the physical world. He re-creates Internet phenomena in the real world. For example, CAPTCHA codes, small images of a randomly generated letter-number combination we encounter online and which we have to decode and reproduce in order to prove to the server that we are human, not computers, become graffiti on walls; real human beings are invited to 'play' their avatars from the video game *World of Warcraft*; and QR codes — two-dimensional bar codes for storing numerical information — are transformed into real charcoal drawings and exhibited in a gallery. The leitmotif of his work is the conflict between the public and the private domain, the *online* and the *offline*.

Reproducing a virtual object in real life often means increasing its size. This was the case for the public art installation Map, which represents the famous Google Maps marker: the red A.

In Arles, but also in Berlin, Cassel (Germany), Taipei (Taiwan) and Szczecin (Poland), Aram Bartholl transformed this Internet icon into a real physical pin and positioned it exactly in the location which, according to Google Maps, is the centre of the city.

The size of the real-life red marker corresponds exactly to the size of the marker in the web interface when the maximum zoom factor is applied (20 pixels). Transferred from the screen to physical space, the red pin emphasises how our perception of the city is increasingly influenced by geolocation services. It is said that the idea for this work came to Aram Bartholl one evening when friends claimed to be unable to visit him because Google Maps did not show his apartment. Dumbfounded, the artist asked himself the question: is it possible to exist in real life if we don't exist in virtual reality?

Opposite and following double page: *Map,* 2013, 6 × 3.5 × 0.35 m, wooden planks and nailing strips, paint, cables, screws, adhesive, nails, Kassel, Germany

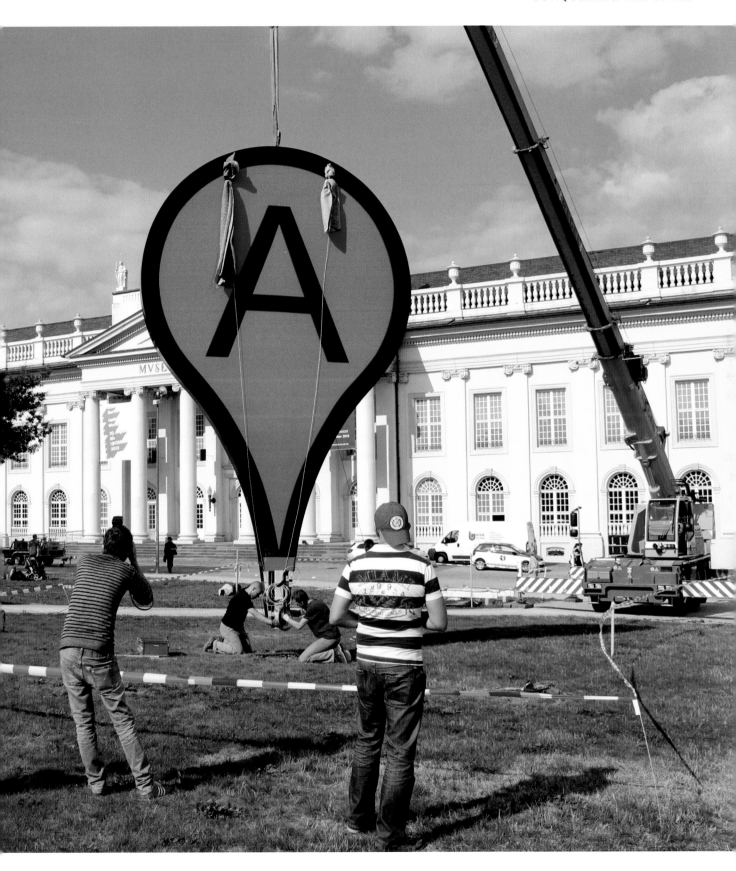

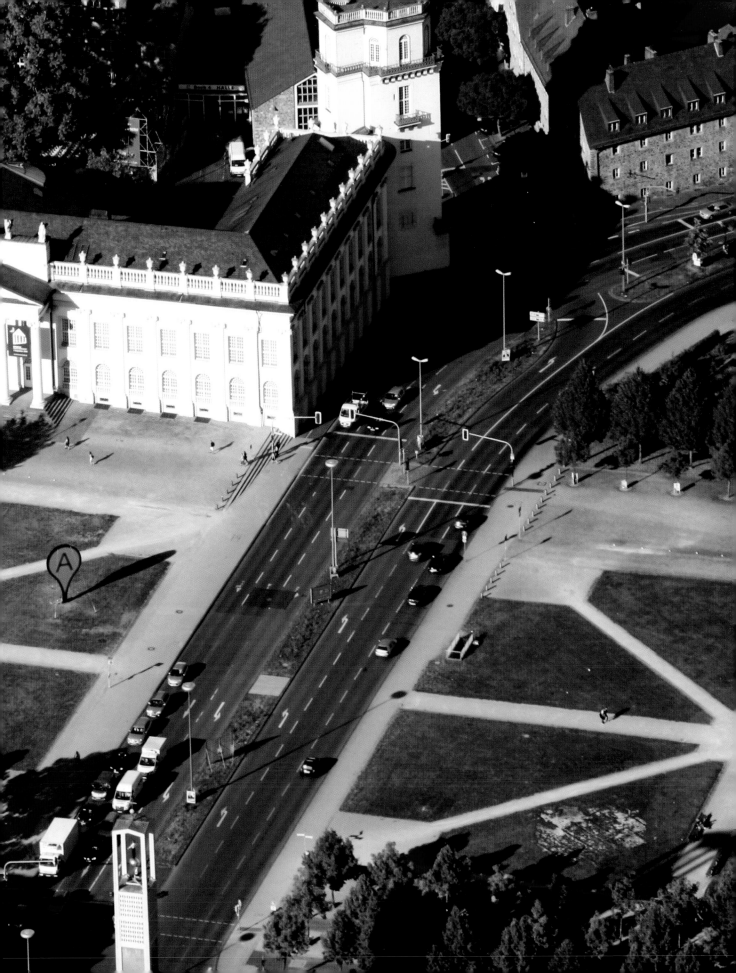

OSGEMEOS

(b. 1974)

Gustavo and Otávio Pandolfo, identical twins ("gêmeos" in Portuguese) come from São Paulo and have been painting their giant, surrealist yellow-skinned figures on walls all over the world for more than twenty years.

In the late 1980s, the hip-hop movement, which originated in the United States, came to Brazil. The Pandolfo brothers were fascinated and began to dream of becoming graffiti artists. But at the time, in Brazil, there was little information available on the techniques and methods used, and there was also a lack of appropriate materials (spray paint in Brazil was of poor quality, the range of colours was limited, etc.). OSGEMEOS did the best they could with what was to hand, improvising and creating their own unique style. Their reputation spread, and they met the legendary San Francisco street artist Twist—better known today under the name Barry McGee—who took them under his wing and sent them all the materials they needed from the United States. Now nothing could stop the two graffiti artists.

Their inimitable style takes its inspiration from folklore, the colours and social problems of Brazil and more particularly of the city of São Paulo. Both social and political, their work represents their view of their country. And they refer to their obsession with the colour yellow as "evident" right from their very first paintings.

In 2012, the twins were more famous than ever before: the Institute of Contemporary Art in Boston offered them their first solo exhibition in the United States. As part of this retrospective, OSGEMEOS were invited to do what they love best: to paint a huge mural on a wall in the city. The work, *The Giant of Boston*, shows a young boy in pyjamas who has covered his head with a shirt.

Masked figures are a recurring theme in the works of OSGEMEOS: they are a reference to the taggers who cover their faces to avoid breathing in the toxic fumes from their spray paint and also so that they cannot be identified.

The Giant of Boston, 2012,
21 × 21 m, painted mural, Dewey Square, Boston, United States

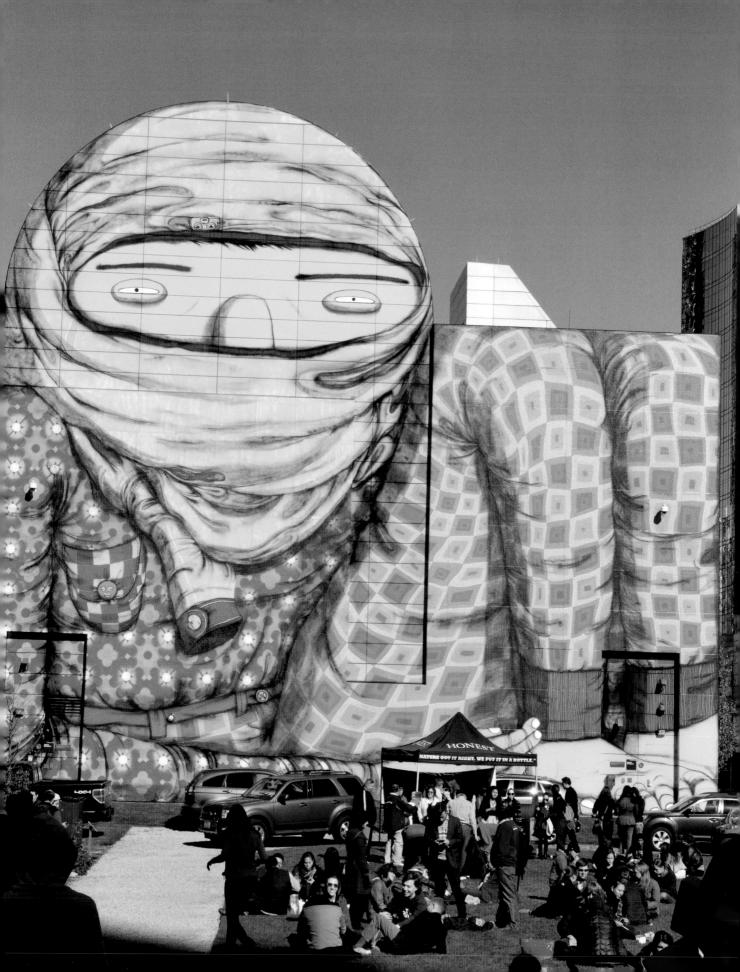

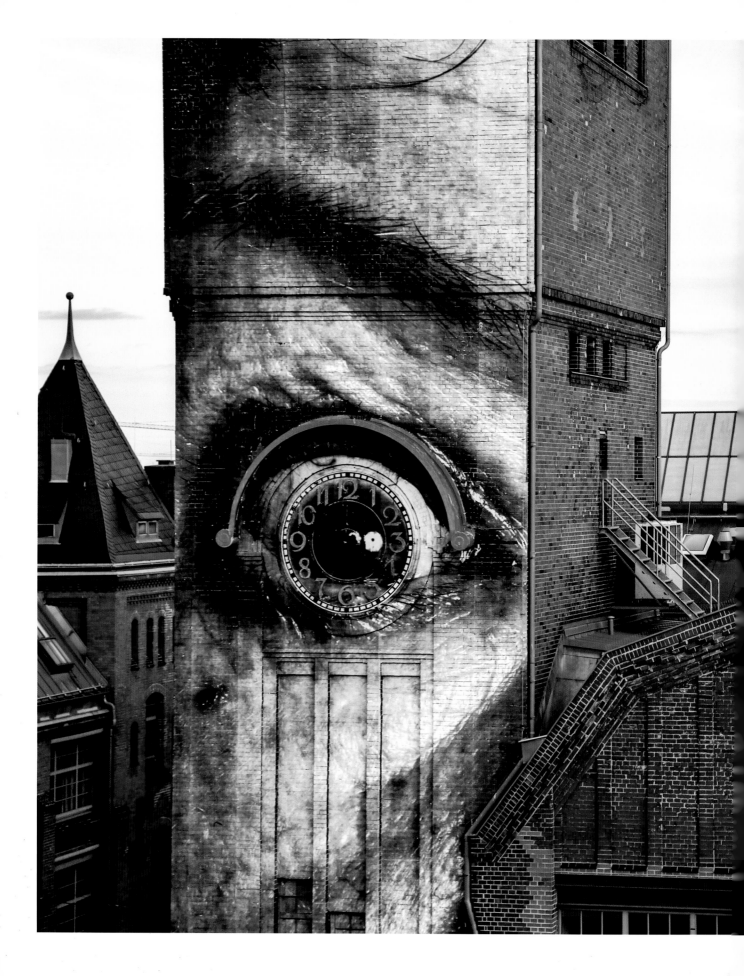

JR

(b. 1983)

A hybrid artist who is equally at home in the world of *street art* and photography, JR roams the planet to paste his giant images anonymously in urban locations. People all over the world have been able to admire his work: in the suburbs of Paris, on the wall separating Israel and Palestine, on trains in Africa or in the Brazilian favelas.

As a teenager, JR was more interested in graffiti art, until he found a camera on the Paris underground and discovered a passion for photography. Within just a few years, this self-taught genius was posting his typical artworks all over the world: blown-up black and white portraits pasted in public locations in the form of XXL posters. His art confronts and engages the viewer and is entirely participatory. The inhabitants of the towns and cities he visits are invited to take part in the creation of his work by posing for photographs and then helping the artist and his team to put up the gigantic enlargements.

In 2008, the "urban artivist" and philanthropist launched his *Women Are Heroes* project, a homage to the women who suffer in silence all over the world. He travelled to several African cities, visiting, for example, the shantytown of Kibera in Nairobi (Kenya). JR applied a special technique here: instead of creating simple posters, he printed the images of the women on 2,000 m^2 of waterproof fabric with which he covered the roofs of the slum and trains travelling through the area. In the same year, he took *Women Are Heroes* to Morro da Providência, a favela in Rio de Janeiro notorious for its violence. The young French artist covered the outside walls of houses in the slum with portraits of its female inhabitants, the victims of drug trafficking, which thrives in the area.

The Wrinkles of the City takes as its subject a completely different social group: the elderly. JR travelled to the cities of Cartagena, Shanghai, Los Angeles, Havana and Berlin to photograph their older residents. The wrinkled faces of this easily forgotten generation bear witness to their individual stories, just as the buildings on which JR chose to display the images reflect the history of the city and the changes which have taken place there.

Opposite: *The Wrinkles of the City*, **2013,** various dimensions and materials, Berlin, Germany

Following double pages:
Women Are Heroes, **2009,** various dimensions and materials, Kibera Slum, Kenya
Women Are Heroes, **2008,** various dimensions and materials, Favela Morro da Providência, Rio de Janeiro, Brazil

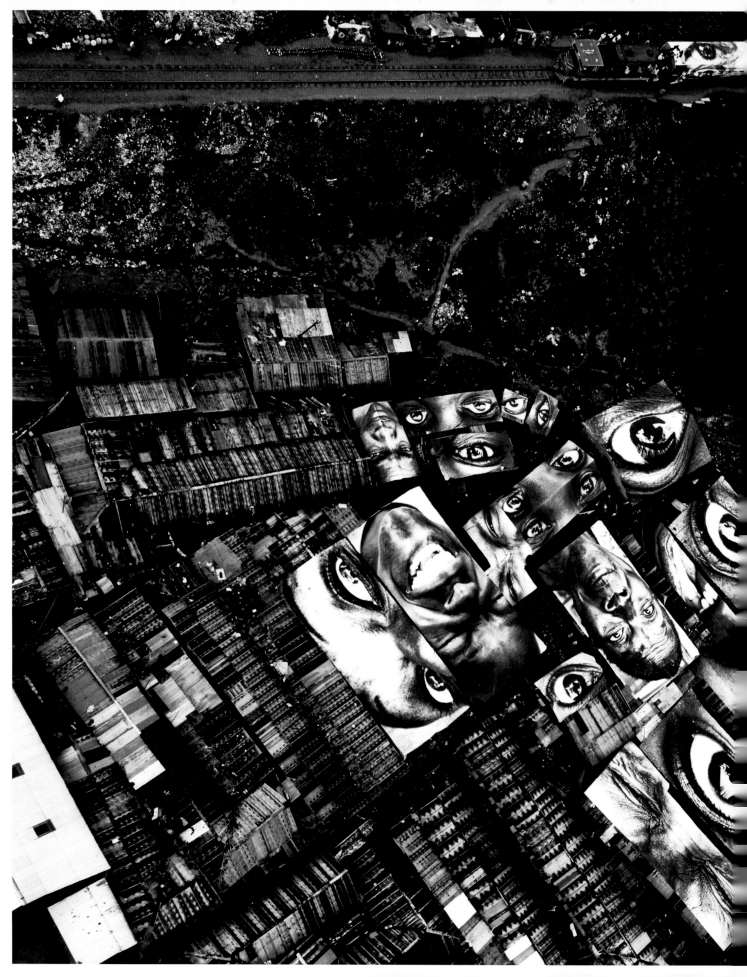

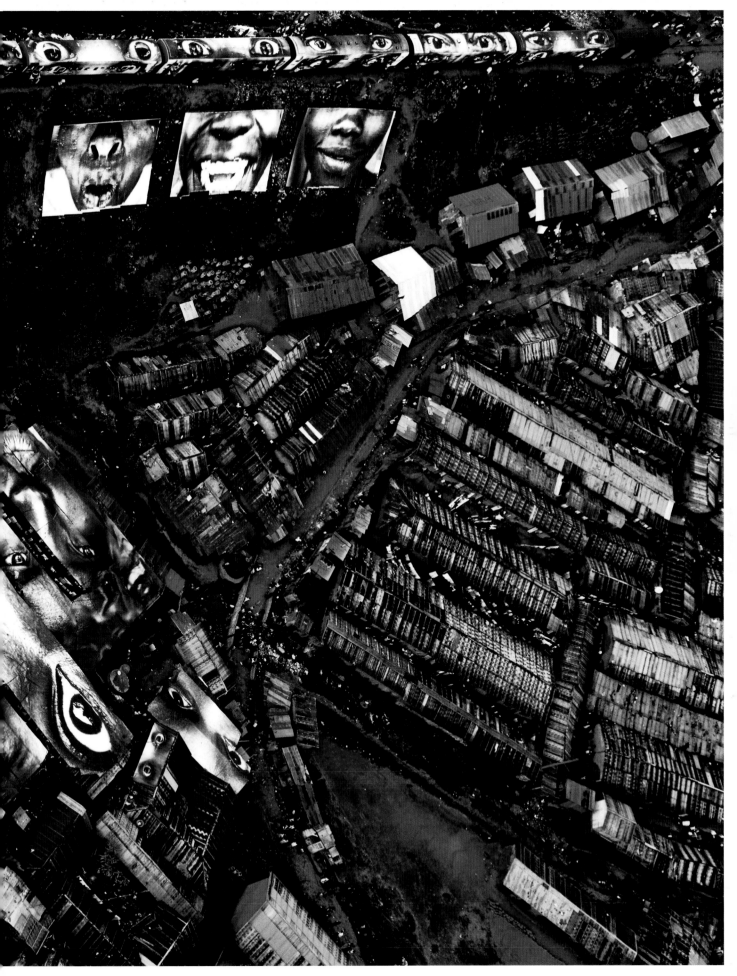

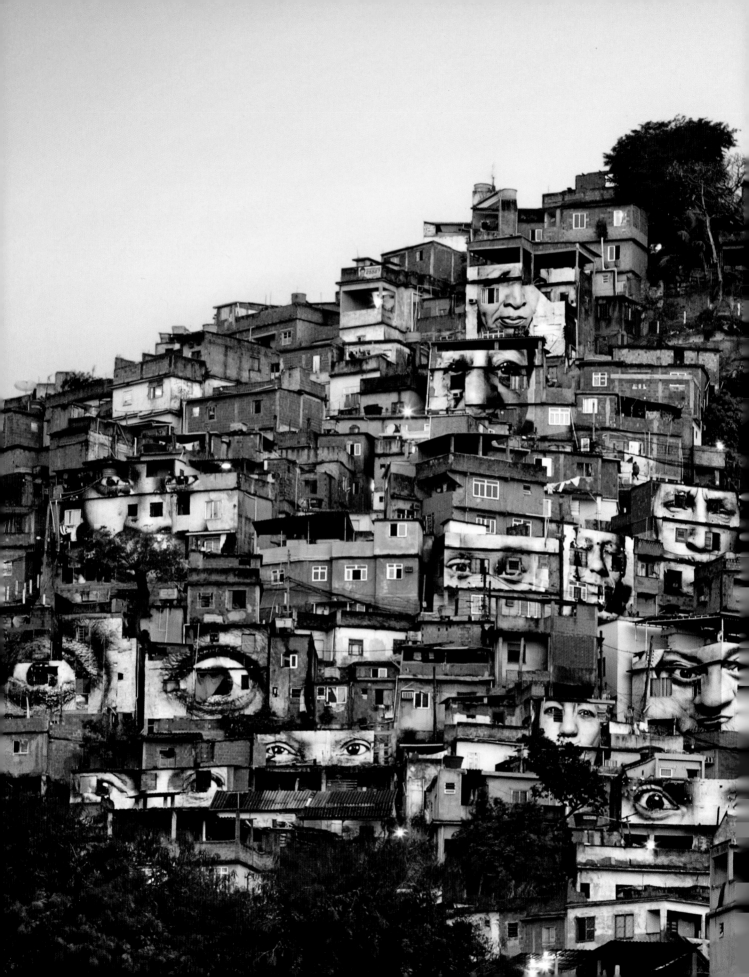

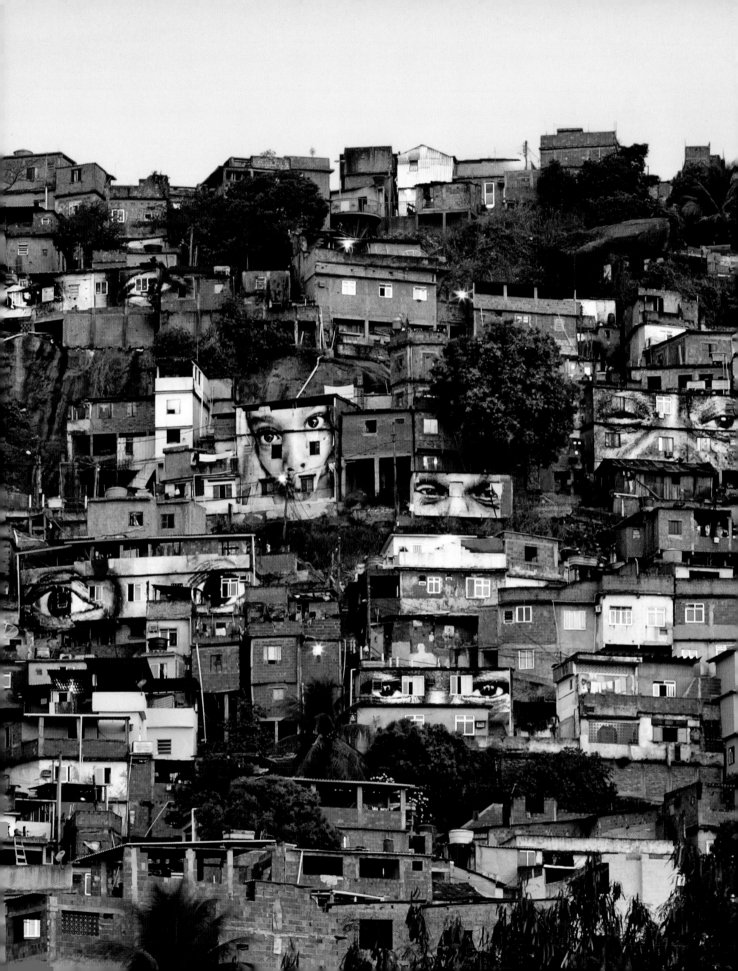

ADEL ABDESSEMED

DAMIAN ORTEGA

DANIEL FIRMAN

FIONA BANNER

JOANA VASCONCELOS

PUSHING THE BOUNDARIES

MAURIZIO CATTELAN

PHILIPPE PERRIN

RICHARD SERRA

RON MUECK

ZHANG HUAN

Originally, museums were the province of the aristocracy or the enlightened bourgeoisie. In the West, the Enlightenment dreamt of a space accessible to all and serving to educate the masses. In France, this was achieved with the French Revolution, when works of art taken from the homes of the nobles or from churches were exhibited publicly, for example in the Palais du Louvre. Nevertheless, these places continued to be frequented mainly by aesthetes and the well-educated. Due to lack of funds, they were often poorly maintained, and the trend did not envisage making learning fun. It was not until the 20th century, especially from the 1970s onwards, that museums became a tourist attraction, triggering a wave of new openings all over the world. Museums and art galleries flourished in most cities, much to the chagrin of those who protested against beer and pie museums which no longer fitted in with highbrow theories of an aesthetic and scientific culture accessible to all. Faced with competition from attractions with more popular appeal, traditional art establishments were forced to rethink. By pimping up their image and modernising, they attracted a broader audience. The artists themselves had a new vision of these exhibition spaces, especially as they now had the technological means to adapt the existing space to the work displayed. Museums are often housed in buildings of imposing dimensions, for example palaces, and architects today are aware that they need to provide adequate space for large-scale works of art. Locations and events designed specifically to display monumental art were created, for example the Tate Modern's Duveen Galleries, which hosted exhibitions of works by Ai Wei Wei (see pages 162–163) and Fiona Banner (see pages 118–121) or the

"Monumenta" (see Anish Kapoor, pages 158–161, and Daniel Buren, pages 66–67), which stages an annual temporary exhibition of large-format art-works. These are normally held within the walls of institutions, as they require considerable manpower and involve lengthy installation periods. But museums are well aware that these impressive works, so massive that they seem to be trying to push the boundaries of the exhibition space, are guaranteed to be a lasting success with the public.

Pages 98–99:
Cai Guo-Qiang (see pages 70–71)
Head On, **2006, 2009,**
various dimensions, gauze, resin and painted skins, glass wall, Guggenheim, Bilbao, Spain

Pages 100–101:
Ron Mueck (see pages 106–109)
Still Life, **2009,**
215 × 89 × 50 cm, various materials, Cartier Foundation, Paris, France

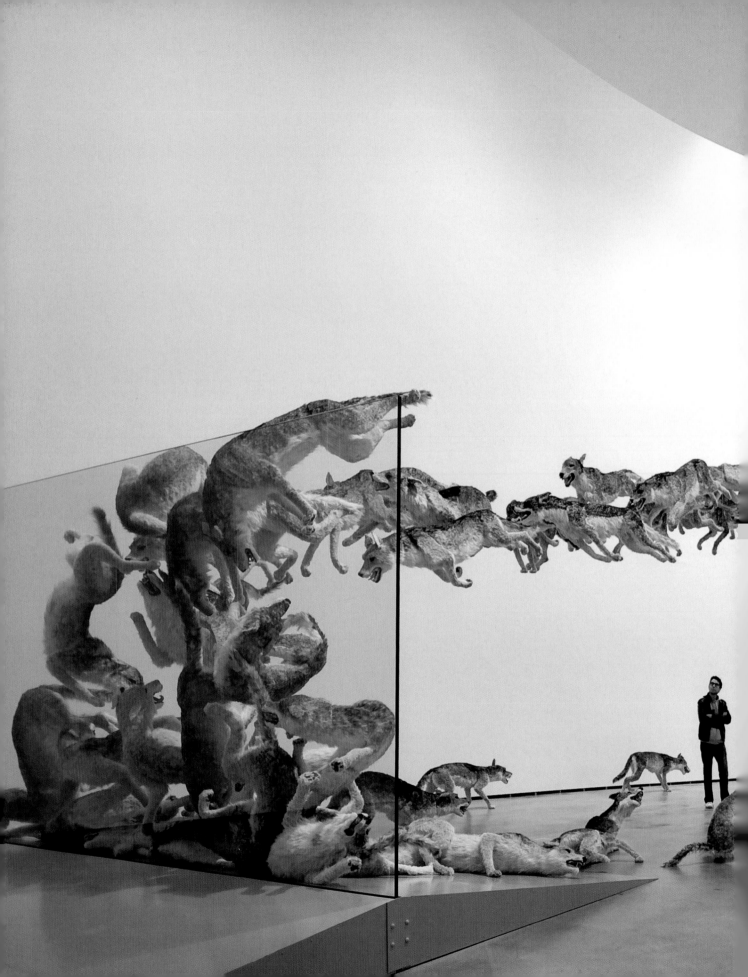

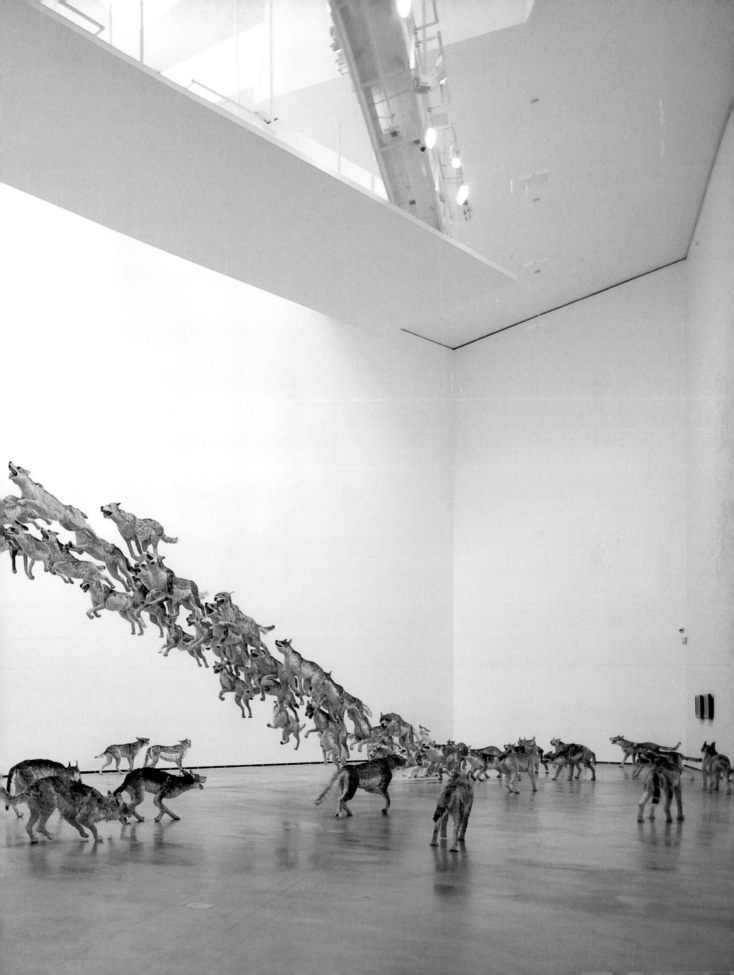

RICHARD SERRA

(b. 1939)

American artist Richard Serra is best-known for his monumental sculptures. In 1967, he began to compile a list of verbs such as "to roll," "to gather," "to bend" …, describing actions which he decided to apply to his creative process. They served almost as directives the sculptor imposed on himself while working his steel plates. *The Matter of Time* and *Promenade* demonstrate his consummate command of space.

Designed as site-specific installations, Serra's sculptures organise or redefine the location, which becomes an integral part of the work. Their raw material, steel, seems to defy the laws of physics: aerial, immense and with patches of rust, the plates seem frozen in equilibrium. *The Matter of Time*, exhibited at the Guggenheim Museum in Bilbao, comprises eight independent structures which, taken together, create a passageway through which visitors to the gallery move. The first of these structures, a serpentine, was erected in 1994, the others in 2005. Speaking of *Promenade*, Serra said "The content is within the visitor. It's not simply about huge steel plates in the air, the subject matter is your own experience […] The manner in which the space is occupied and the temporal aspect of this work constitute the subject matter, depending on how the visitor understands this sculpture," but this could be said to apply to all his steel sculptures. Like *The Matter of Time*, *Promenade*, which was exhibited in the Grand Palais in Paris at the Monumenta 2008, plays with space and the spectator's perception. The title itself, *Promenade*, is an invitation to walk amidst all this volume and to contemplate the various "landscapes" created by the five rectangles contrasting radically with the verticality of the location.

Promenade, 2008,
4 × 17 m, steel, Grand Palais, Paris, France

Following double page:
The Matter of Time, 1995 and 2005
various dimensions, steel, Guggenheim, Bilbao, Spain

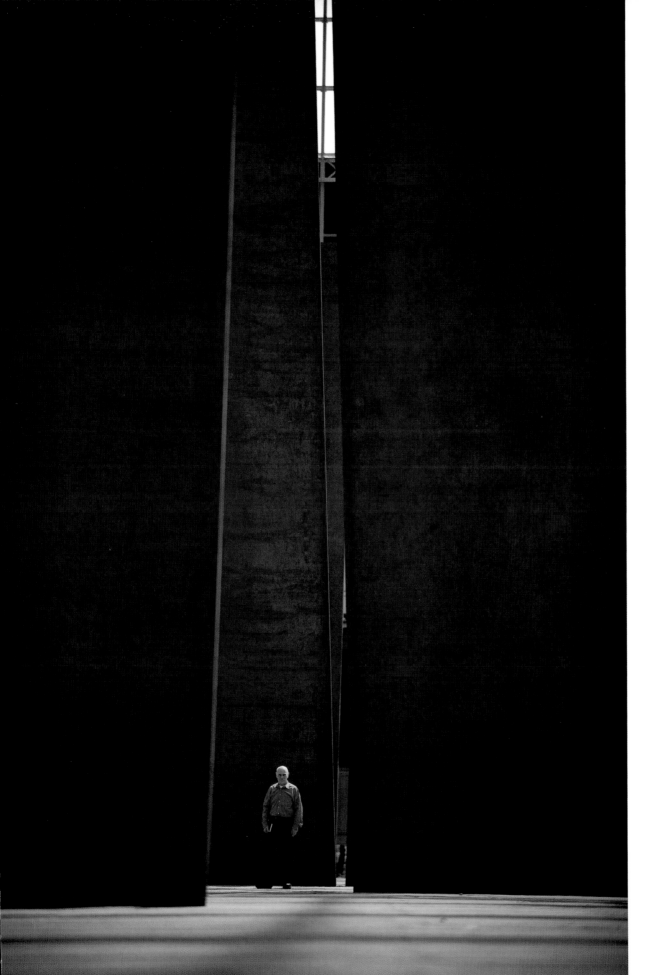

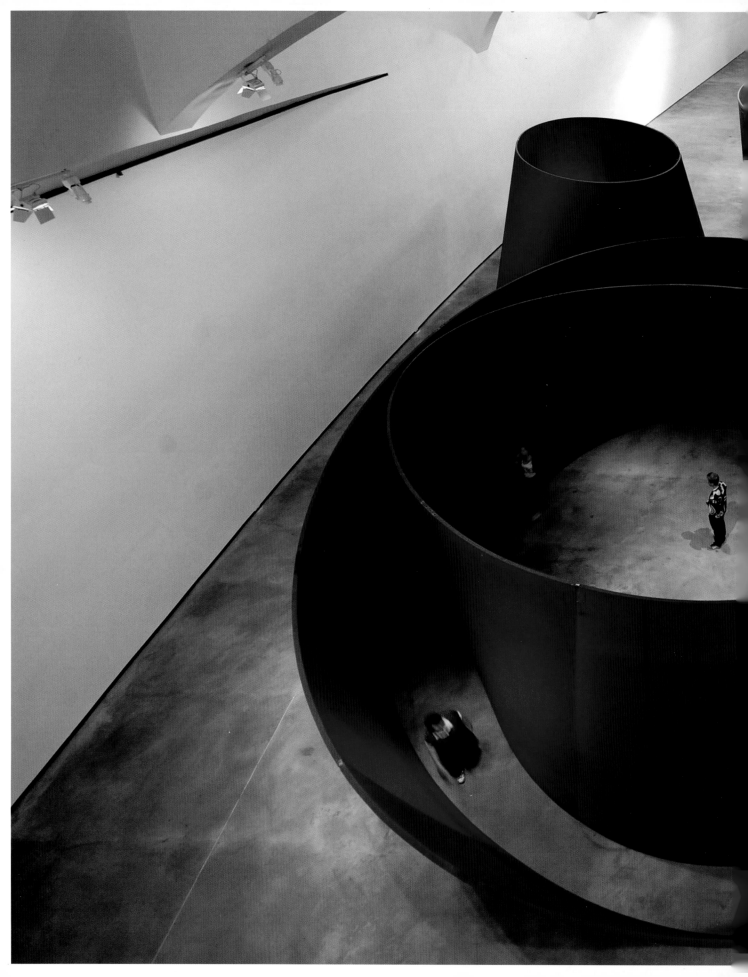

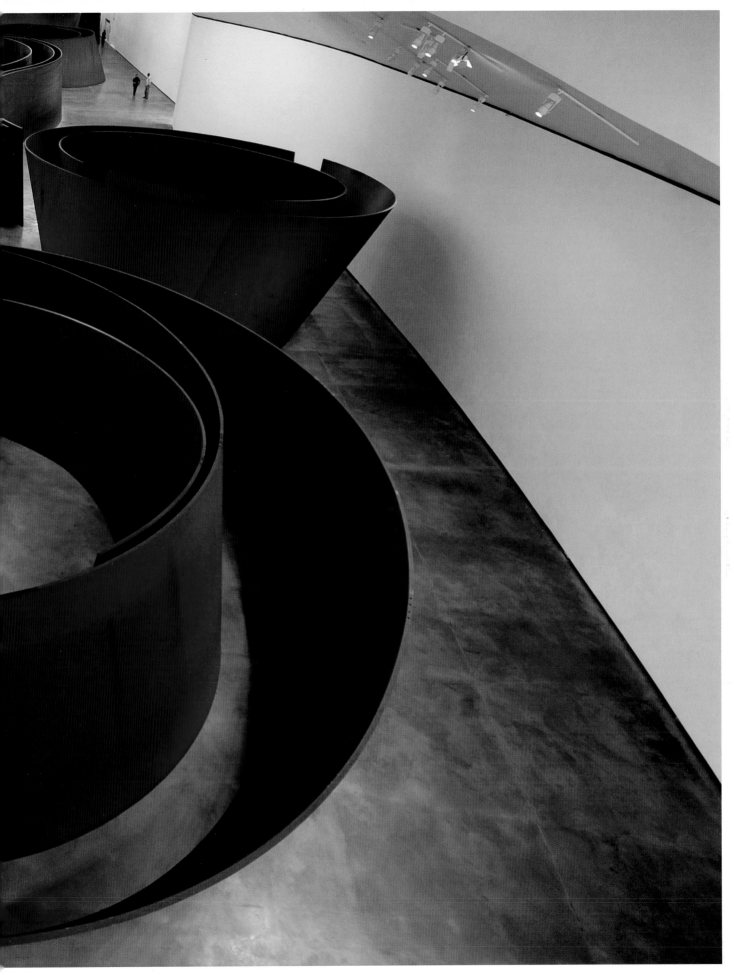

RON MUECK

(b. 1958)

Ron Mueck exhibits all over the world; the disturbing realism of his works intrigues, amuses, repulses or fascinates… and attracts record numbers of visitors at museums or galleries. Although the sculptor claims that it was never his intention to become an artist, he has an outstanding talent for reproducing the body, generally the human body, in minute detail. The only thing which is not realistic about Mueck's creations is their size: too small or gigantic, their misrepresented scale makes them all the more disconcerting.

The environment in which Ron Mueck grew up influenced his art: his father sculpted wood and his mother made rag dolls. Mueck began his career making puppets for television, notably for the "Muppet Show," and cinema; his talent opened the doors of the art world to him. His extremely complex technique allows him to faithfully reproduce the minutest details, but requires many hours of painstaking work, which he supervises throughout. Hair is implanted on the hands, every vein and every nuance is carefully painted, no detail is left out. Despite their gigantic dimensions, it could be said that Mueck's figures often appear weak rather than menacing. *Boy* is a five-metre-high figure of a young boy in the pose of an Aborigine hunter. And yet, far from looking like a predator, this young giant with an expression of distrust in his eyes seems to be trying to protect himself, perhaps against the inquisitive eyes of the onlookers. In the same way, *Wild Man* appears terrified of his tiny admirers, pretending not to see them by turning his head. His stiff posture, his hands tightly gripping the stool and his nudity all suggest fear and weakness. Mueck's figures are extremely commonplace, far from the magnified images projected by the media; they show man with all his physical defects, without shame and undisguised: ageing, flaccid, coarse, pale bodies… nothing escapes his descriptive talent. Ron Mueck is an artist who displays the flesh stripped of all complacency.

Wild Man, 2005,
28.50 × 16.19 × 10.80 m, various materials (silicone, polyester resin, oil paint), Tate Modern, London, United Kingdom

Following double page:
Boy, 2001,
5 × 5 m, various materials (silicone, polyester resin, oil paint), ARoS Aarhus Kunstmuseum, Aarhus, Denmark

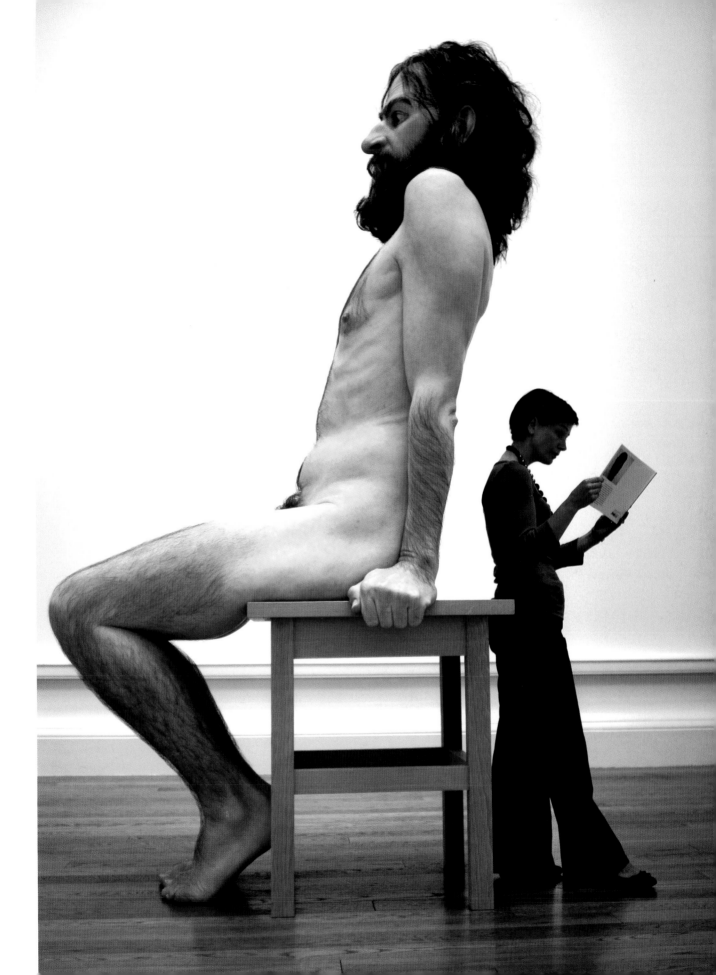

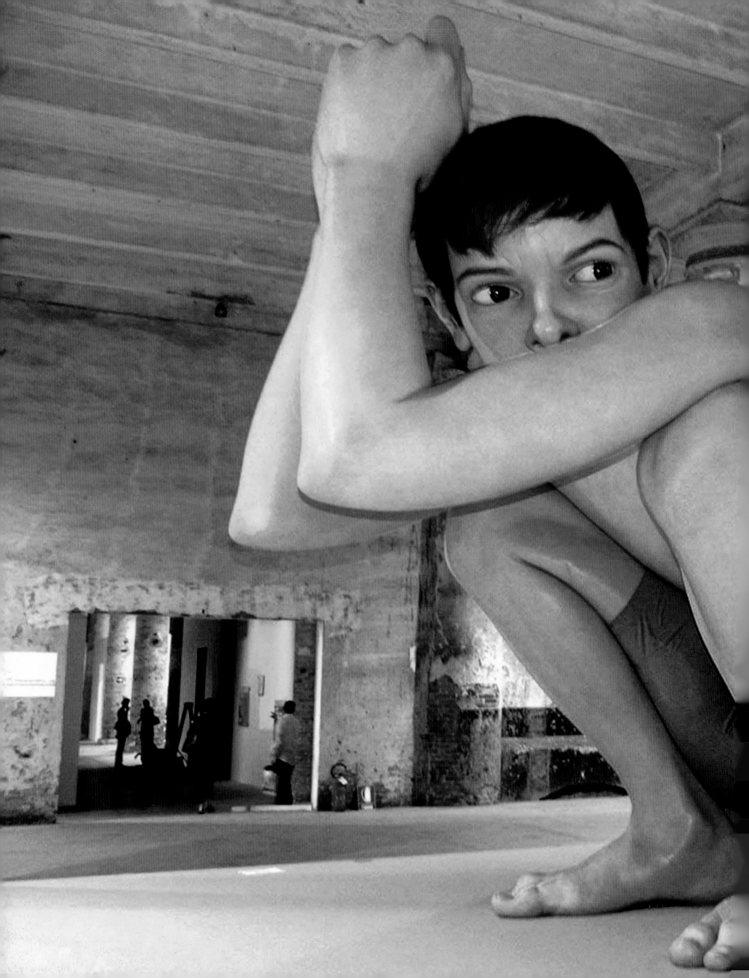

MAURIZIO
CATTELAN
(b. 1960)

Maurizio Cattelan is a master of provocation. Acclaimed in the international art world, he triggers enthusiasm or anger with works which very often throw political correctness to the winds and mock the taboos of our age, for example *Him*, a sculpture of a kneeling Hitler, or *Nona Ora*, showing an effigy of Pope John Paul II being crushed by a meteor. *L.O.V.E* (see pages 52–53), a huge extended middle finger evoking a rude gesture, was no stranger to scandal, either.

This white marble hand was erected in 2011 on the Palazzo Reale in Milan, during an exhibition of Cattelan's work entitled "Against the Ideologies." Positioned in front of the stock exchange, the four-metre sculpture (11 metres high including the pedestal) seems at first glance to be giving the business world the finger. Cattelan himself stated that it was not his intention to insult the world of finance and offered various other interpretations, including a criticism of fascism. And in fact, the other fingers of the hand are not folded over, but depicted as if cut off, so if one imagines that they were replaced, the hand really would resemble the 20th-century Italian Fascist salute. "Officially, its name is L.O.V.E.—so it stands for love—but everyone can read between the lines and take away the message they see for themselves," the artist explains.

A retrospective of his work at the Guggenheim in New York in 2012 once again gave Cattelan the opportunity to demonstrate his originality. Instead of allowing his works to be displayed conventionally in neat chronological order in the museum's exhibition halls, he envisaged an incredible creation. *All* comprises the fruits of the last twenty years of his career as an artist: the 128 works are suspended from the roof in one gigantic mobile, far from any sacralisation of art. Viewers can pick out the famous figures of *Him* and *Nona Ora*. More than a mere retrospective of the artist's past creations, this huge suspended installation becomes a self-contained work in its own right.

All, 2011–2012,
various dimensions and materials, Guggenheim, New York, United States

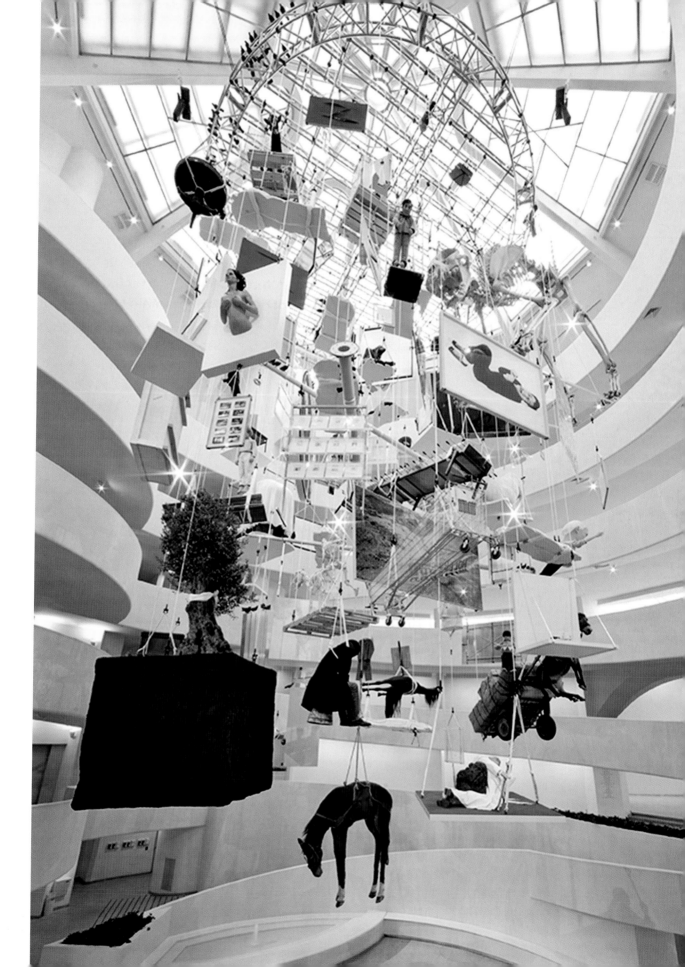

PHILIPPE
PERRIN
(b. 1964)

A former boxer turned artist, Philippe Perrin has something of the bad boy: rock-star looks, an explosive temperament and a shady past which he likes to allude to when talking to journalists. He cultivates his subversive image by creating provocative artworks revolving around the subjects of evil and crime.

A real loose cannon on the contemporary art scene in France, an artist for whom art is a "curse," he has worked with many different media: photography, writing, sculpture, video, drawing, the cinema etc. He takes his inspiration from such widely ranging sources as mediaeval poet and outlaw François Villon, the subversive punk band The Clash, the controversial painter Caravaggio, pre-revolutionary highwayman and smuggler Louis Mandrin or dadaist poet and boxer Arthur Cravan. Much of Philippe Perrin's work has as its subject acts of violence, for example his reconstruction of the car belonging to infamous criminal Jacques Mesrine (*Hommage à Jacques Mesrine*, 1991), the presence of living persons in installations depicting murders (*Bloodymary*, 1993) or portraits of himself as a murderer, weapon in hand (*Nice is nice*, 2001). Visually, his most striking works are his gigantic sculptural reproductions of objects connected with crime. For example, his works have depicted Kalashnikov bullets over two metres high, a 3.20-metre handgun (*Gun*, 2002) or a 4-metre scalpel. Breaking all artistic taboos, he even gave permission for one of his giant works— a knuckleduster—to be used in the making of a pornographic film.

In 2006, he presented *Heaven*, a circle of barbed wire with a diameter of 3.4 metres created for installation in the chancel of the church of Saint Eustace (Paris). Except for its size and the material used, the work resembles Christ's crown of thorns. The title *Heaven* is an allusion to *Stairway to Heaven* by Led Zeppelin, a song reputed to contain Satanic references if played backwards. By the same principle, in placing this crown of thorns at floor level, where it is closest to the entrance to Hell, Perrin could be said to have subverted the sacred place itself. The coldness of the metal, its gigantic dimensions and theatrical lighting serve as a brutal reminder to the spectator of the violence of murder.

> " PHILIPPE HAS ALWAYS BEEN ADDICTED TO OVERSTATEMENT: AND SO THE MILLIMETRES BECAME METRES. "
> Jean Nouvel

Gun, 2002,
length: 3.20 m, cast aluminium, stainless steel, grip resin or wood, Musée d'Art et d'Industrie, Saint-Étienne, France

Following double page: *Heaven,* 2006,
3.4 m in diameter, cast aluminium, church of Saint Eustace, Paris, France

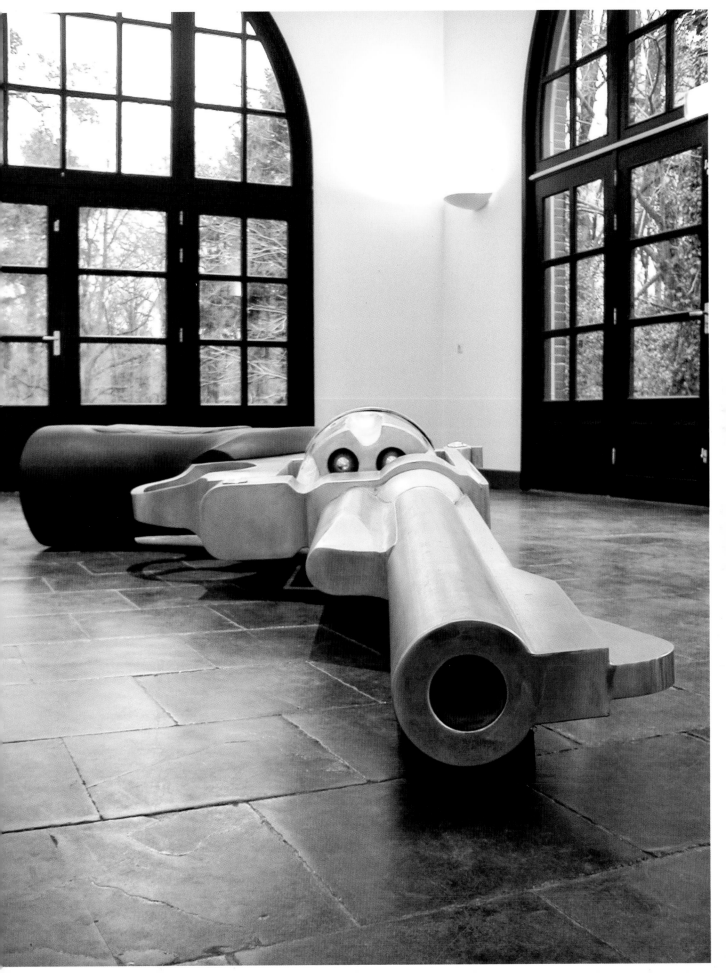

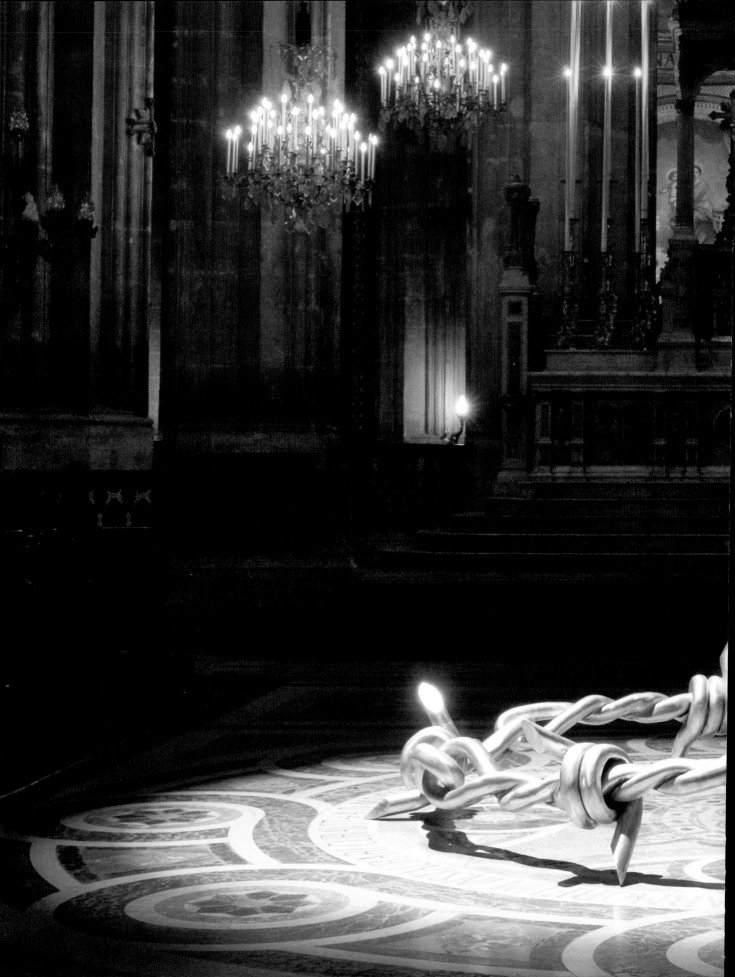

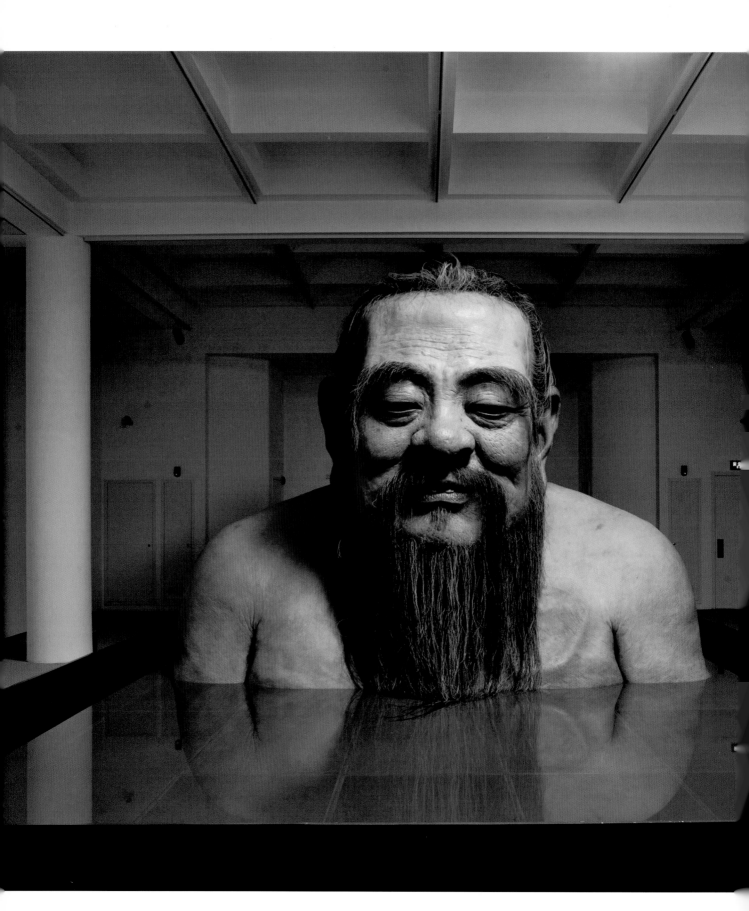

ZHANG HUAN

(b. 1965)

Inspired by an ancient portrait of Confucius, *Q Confucius No.2* is a statue almost 10 metres high, equipped with a mechanism that makes its breast rise and fall as if the silicone giant were breathing. The work was the centrepiece of an exhibition of the same name held in the Art Museum Rockbund in Shanghai.

After living in the United States for some years, Zhang Huan decided to return to his native China. Despite his refusal to imbue his work with political meaning, understandable in view of the threat of reprisals, the artist's work nevertheless reveals a deep interest in humanity, and especially in questions of faith, the history and future of societies. The artist is principally famous for his paintings and sculptures made from incense ash, which he collects from temples, some of them depicting religious figures such as Jesus or Buddha. 46 years old when he presented *Q Confucius No.2*, Zhang Huan reflected on questions concerning the future of mankind and of his country: "Faced with rapid economic and societal changes and energy, climate, and environmental challenges, how can human beings achieve sustainable and harmonious development? What responsibilities come with China's rise in international prominence and power? Where is the sense of spiritual belonging for contemporary Chinese?" This sculpture of Confucius illustrates that thinking process. Three-quarters submerged, the philosopher's body seems to disappear beneath the opaque water of the pool. His advanced age symbolises experience and wisdom, but the vast scale of the statue makes the defects of old age more visible: blemished and wrinkled skin, yellowing teeth and an enlarged nose... Do these represent the death of Confucianism or at least its decline? Does the sculpture symbolise a search for the cold, naked and sometimes ugly truth through the medium of art? Whatever the answer may be, the giant goes on calmly breathing, as if to prove that he is still alive.

Q Confucius No.2, 2011,
3.8 × 9.8 × 6.6 m, silicone, steel, carbon fibre and acrylic, Art Museum Rockbund, Shanghai, China

FIONA
BANNER
(b. 1966)

Appearances can be deceiving: this is not a photograph taken in an aircraft museum, but in an exhibition of contemporary art at the Tate Britain in London. *Harrier* and *Jaguar*, huge decommissioned fighter planes in the incongruous neo-classical setting of the Duveen Galleries, were at that time the largest works to have been created by British artist Fiona Banner.

Displayed in a startling manner, like hunting trophies—the *Harrier* suspended nose-down from the ceiling, while the *Jaguar* lies belly up on the floor –, these two fighter planes, which saw active service before they were acquired by the artist, look like wounded animals, a comparison which is rendered all the more evident by the names from the animal world (a harrier is a hawk). The artist also painted feathers on the *Harrier*, accentuating the bird image. The planes are also placed in an unusually vulnerable position. While Fiona Banner is not making an anti-war protest, the installation nevertheless confronts spectators with their own response to these instruments of destruction. Reactions to such an installation can be disturbing: the murderous potential of the exhibits does not prevent visitors succumbing to the beauty of the machines and feeling oddly drawn to their power. The artist has modified the two aircraft to this purpose: by painting feathers on the Harrier's wings and stripping and polishing the Jaguar to emphasise its harmonious lines and mirror the reflection of visitors in its surfaces. These objects, now appropriated by art, were quite evidently not created to be beautiful, but with a purely functional aim: they were designed to kill. The artist poses the question: is it then morally defensible to admire them?

Fascinated by war, the theme of the combat plane runs like a common thread through Fiona Banner's work, in the form of pieces of aircraft equipment (*Tornado Nude*, 2006), model planes (*Parade*, 2006) or press cuttings (*All The World's Fighter Planes*, 1999–2009).

Harrier, **2010,**
7.6 × 14.2 × 3.71 m, BAe Sea Harrier aircraft, paint, Tate Modern, London, United Kingdom

Following double page: *Jaguar,* **2010,**
8.69 × 4.92 × 16.83 m, polished Sepecat Jaguar jet, Tate Modern, London, United Kingdom

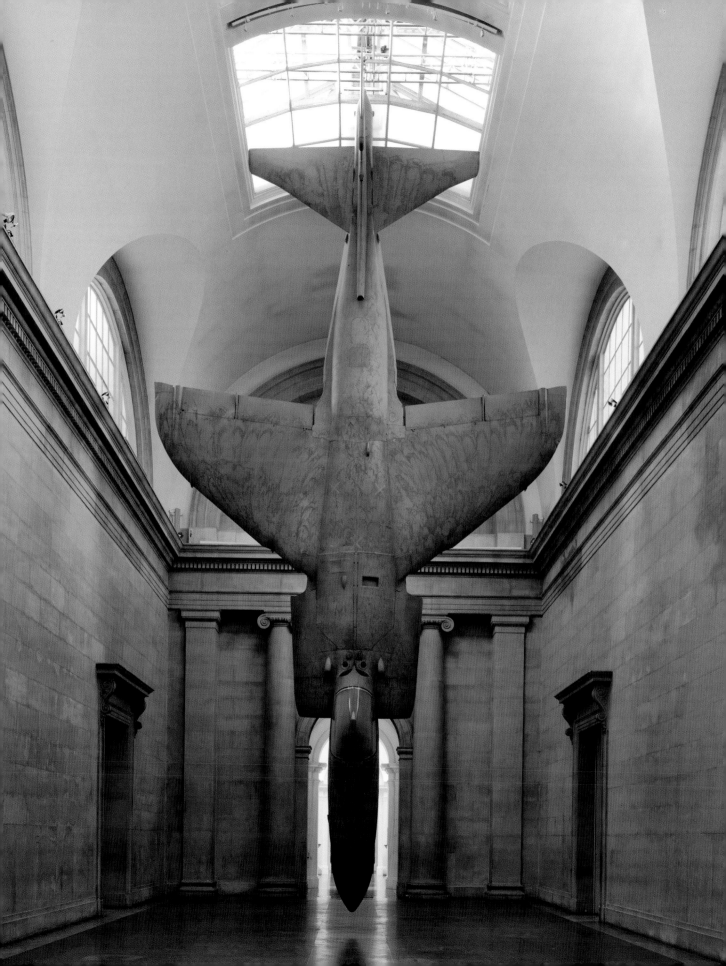

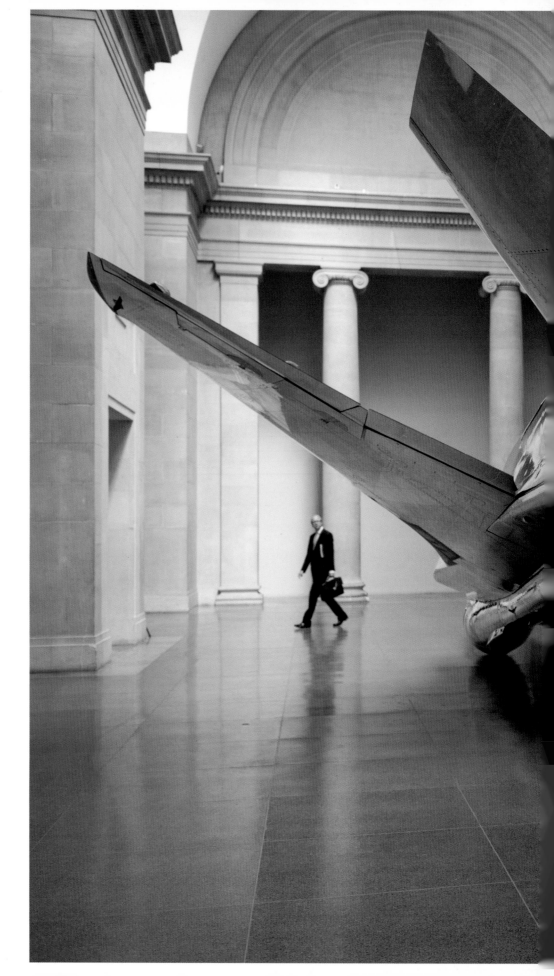

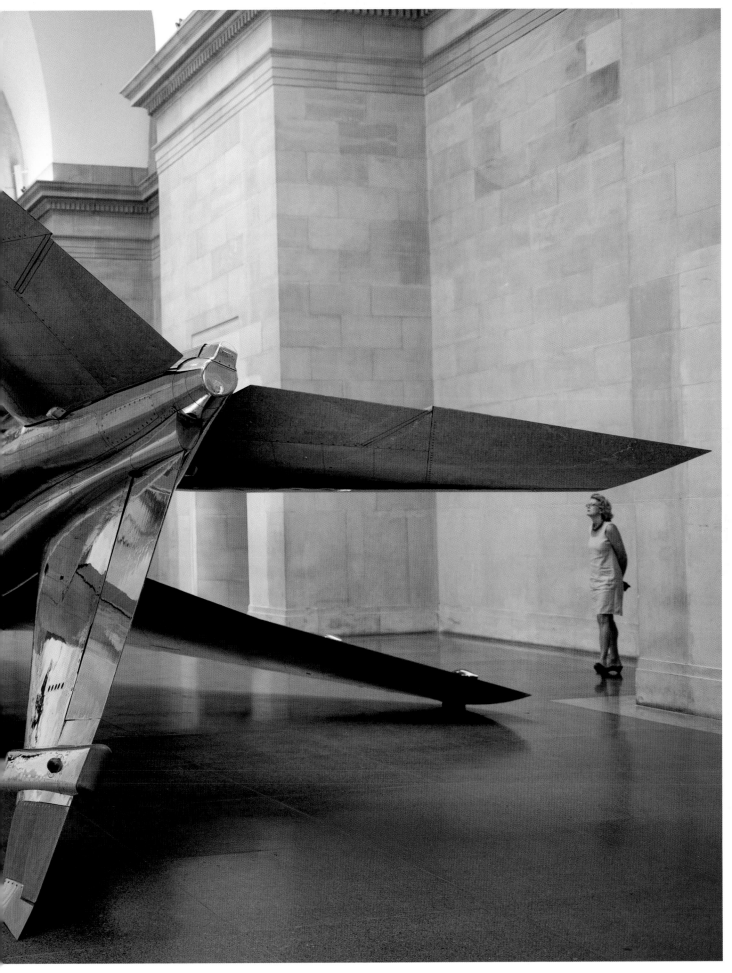

DANIEL
FIRMAN

(b. 1966)

Frozen in a seemingly impossible balance, an elephant—the heaviest land animal!—floats like a party balloon between the gilding, carved wood and painted ceilings of the Palace of Fontainebleau. Daniel Firman, an important representative of the French art scene and fascinated by the laws of equilibrium, is the creator of this work of art.

On entering the Galerie de Diane during the exhibition "Château de Tokyo / Palais de Fontainebleau" in 2008, visitors found themselves face to face with this spectacular life-sized pachyderm, which seems to defy the law of gravity. Why? The answer lies in the title of the work: artist Daniel Firman calculated that 18,000 km above the Earth, *Würsa* the elephant could really balance on the tip of its trunk. According to the artist, installed in "terrestrial" reality, this work modifies our conception of space through a "disruption of gravity," a seemingly floating work of art which modifies our perceptions. Onlookers are invited to enter into a spectacular physical and psychological experience. The feeling of unease is accentuated by the fact that the beast is hyper-realistic. If *Würsa* seems realistic, it is because the artist has covered his polyester sculpture with the skin of a circus elephant, specially prepared by a taxidermist.

Würsa has a horizontal "counterpart" called *Nasutamanus*, created in 2012. Like *Würsa*, *Nasutamanus* has only one point of contact with the earth, namely the tip of its trunk, but in this case, it is attached to a wall. These are the first two in a three-work elephantine series, and the third instalment is awaited with impatience.

Würsa 18,000 km above the Earth, 2006–2008,
5.7 × 2.5 × 1.4 m, elephant sculpture/taxidermy, Palace of Fontainebleau, Fontainebleau, France

DAMIÁN ORTEGA

(b. 1967)

Leading Mexican artist Damián Ortega began his career as a political cartoonist, which may explain not only the mischievous aspect of his works, but also the puns and serious messages which are sometimes coupled with apparent levity. *Controller of the Universe* may be literally an 'airy' work, but this orchestrated explosion of sharp-edged objects, seemingly triggered by some mysterious force, can certainly not be accused of being trivial.

Ortega's art plays with the vantage point of the spectator: *Controller of the Universe* is an explosion, frozen in time, which only becomes clear when you stand directly in front of it. Suddenly, the apparent chaos takes on form, and you see dangerous objects, all pointing forwards and together forming a perfect oval. The empty space in the centre of the installation is directly opposite the viewer's vantage point, with the alignment of the tools and weapons creating the sensation of their being hurled outwards towards the observer, who will only escape being struck thanks to their oblique trajectory. Ortega does not view objects as static, but is fascinated by the idea that if you could see inside something, the interior would be composed of atoms in motion. He says he read somewhere that in Sanskrit, the concept of a 'thing' is understood as the equivalent of an 'event,' leading him to reflect on these notions and apply them to the place and the significance of sculpture. His works can be seen as events which derive their meaning from the ideas and reactions they generate. Objects, and thus also artworks, rely on relations and repercussions and not on the substances they are made from. The artist first attracted international attention in 2003 with a fragmented installation for the 50th Venice Biennale entitled *Cosmic Thing*, for which a Volkswagen Beetle was dismantled and its pieces suspended on wires from the ceiling. The work moves as the spectator walks around it, allowing a new vision of the object. Ortega created monumental works composed of small elements hanging in mid-air, breathing new life into a shape, an object or an idea.

" YOU CAN FIND A SYMPTOM OF SOMETHING BIG EXPRESSED IN A SMALL PARTICLE. "

Controller of the Universe, 2007,
2.85 × 4.05 × 4.55 m, found tools and wire, White Cube, London, United Kingdom

ADEL
ABDESSEMED
(b. 1971)

Since the 1990s, well-known French conceptual artist Adel Abdessemed has been producing colossal and often provocative works of art. He works with a wide range of artistic media such as photography, video, drawing or sculpture.

Adel Abdessemed left his native Algeria in 1994, during the "black decade," a period marked by the conflict between the government and Islamist groups. He travelled first to France, then to New York and Berlin, and finally returned to France, where he continued his work. His art, which always has a powerful visual impact, takes violence as its theme, but without direct reference to the acts of brutality which he witnessed in Algeria. The violence Abdessemed denounces is of a more general kind, the violence intrinsic to existence itself. To this purpose, he transforms it aesthetically, in colossal and sometimes monstrous works such as *Who's afraid of the big bad Wolf* (2011–2012), a gigantic tapestry of impaled and charred animals built to the exact dimensions of Picasso's tableau *Guernica*.

In *Telle mère tel fils* (Like mother, like son), his largest work of art, the cockpits and tail fins of three authentic aircraft are connected by "fuselages" made of felt, woven together to form a braid 27 metres long and symbolising the artist's mother. The work is a tribute to the creativity she required to feed her children in difficult times; today, like her, Adel Abdessemed recycles objects (here, the wreckage of planes) to create.

Habibi ("beloved" in Arabic), one of his key works, is a huge human skeleton together with an aircraft engine turbine. This suspended body reminds us that death is omnipresent in our lives. The title *Habibi* is also a humorous reference to the nickname Abdessemed's wife gives him when he is distracted and absorbed in his books. Literature, like the skeleton for the body, provides a framework for man, and inspires him with his life force.

Telle mère, tel fils (Like mother, like son), **2008,**
27 × 4 × 5 m, aircraft, felt, aluminium and metal, Centre Georges-Pompidou, Paris, France

Following double page: ***Habibi,* 2003,**
21 × 3.5 m, polystyrene, resin, metal (aircraft engine turbine),
St.-Johannes-Evangelist-Kirche, Berlin, Germany

VASCONCELOS

(b. 1971)

Giant placemats, a wrought-iron teapot five metres high or a helicopter covered in pink ostrich feathers… this is the XXL universe of artist Joana Vasconcelos. She has made art of monumental dimensions her trademark, while retaining a sense of detail which makes her works at the same time extremely delicate.

At home somewhere between *ready-made art*, pop art and New Realism, Joana Vasconcelos works by re-appropriating and transforming everyday objects. Her works reflect on problems of identity, of class and above all, on the role of woman in modern-day society. The artist expresses her criticism through gigantic, humorous and transgressive works of art. She needs a whole team of assistants to create art of such monumental proportions: about thirty people (architects, designers, couturiers …) work with her on a permanent basis in a workshop with an area of 1,500 m² in Lisbon. The Portuguese artist, who was born in Paris, was the first female artist invited to exhibit in Versailles. In 2012, visitors to the famous palace could admire one of her key works; *Marilyn*, a giant pair of high-heeled shoes made from stainless steel saucepans, their respective lids and bowls. Positioned at the centre of the legendary Hall of Mirrors, this installation was inspired by the high-heels worn by Marilyn Monroe, the quintessential symbol of desirable and conquering womanhood. The work is an ironic comment on the dual role of woman in modern society: that of seductress and good housekeeper.

Marilyn was not well received by the hardliners of classical art at Versailles, and *A Noiva*, a major success at the Venice Biennale in 2005, was rejected outright by the management of the palace. The work takes the form of a majestic chandelier, six metres high and made from twenty-five thousand white tampons in their packaging. The artist sees *A Noiva* as a tribute to women, inviting us to take a critical look at tradition: what is the point of white bridal gowns today? Joana Vasconcelos wants women to understand that they are now free and to break away from traditional perceptions. The news has apparently not yet reached Versailles.

Marilyn, (PA), **2011,**
290 × 157 × 410 cm, stainless steel saucepans and lids, cement,
Palace of Versailles, Versailles, France

Following double page: *A Noiva* (The Bride), 2001–2005,
600 × 350 × 350 cm, stainless steel, 25,000 OB tampons, cotton thread and steel wire,
António Cachola Collection, Elvas, Portugal

AI WEIWEI

ANISH KAPOOR

ANTONY GORMLEY

BAPTISTE DEBOMBOURG

CHIHARU SHIOTA

DANIEL BUREN

TRANSFORMING THE MUSEUM

DORIS SALCEDO

ERNESTO NETO

FELICE VARINI

JAMES TURRELL

KRIJN DE KONING

TADASHI KAWAMATA

YAYOI KUSAMA

Art *in situ* (which is Latin for "in the place itself") is art intended for a specific location. An *in situ* artwork is often a temporary installation and is created exclusively for the environment in which it is to be displayed, which constitutes an active part of the work. Removed from their intended location, these works of art would take on a new and different meaning. These installations are conceived with the specific location in mind; they only make sense within this environment. And as we have seen in the previous chapters, art *in situ* can be found outdoors, in the countryside or in urban surroundings.

This art form is now also increasingly to be found indoors, in museums and art galleries. Artists are taking over these traditional exhibition spaces for monumental works which cover the floors and the walls, challenging the convention that art is made to be hung on walls. In this context, the work inevitably enters into a dialogue with the surrounding space. Felice Varini (see pages 154–155), who works with indoor architecture, explains his method: "I work on site each time in a different space, and my work develops itself in relation to the spaces I encounter. I generally roam through the space, noting its architecture, materials, history and function. From these spatial data [...], I designate a specific vantage point for viewing from which my intervention takes shape." Krijn de Koning applied the same process in the abbey of Saint-Léonard de Corbigny (see pages 168–169), as did Ernesto Neto in the Panthéon (see pages 170-171) or Tadashi Kawamata in the Pitié-Salpêtrière (see pages 140–141): they all examine the unique history of the location and contextualise the pre-existing architecture through their installations.

However, there are *in situ* artworks which are not created to interact with the history of a specific building, gallery or museum. Of a more versatile nature, they are designed to be installed in different environments, travelling from one location to another, taking possession of and being transformed by each new exhibition space. Examples are the works of Yayoi Kusama (see pages 142–145), James Turrell (see pages 146–149) or Baptiste Debombourg (see pages 174–175). Such works are usually displayed in buildings with a "neutral" history such as modern galleries or museums. Using mirrors, lighting or chipboard to de-construct what we presume to be a familiar and controlled environment, these artists modify our perception of space.

Pages 138–139:
Daniel Buren (see pages 66–67)
Photo-souvenir: Excentrique(s), 2012,
plastic, steel, mirrors, Grand Palais, Paris, France

Pages 140–141:
Tadashi Kawamata (see pages 156–157)
Le Passage des chaises, 1997,
height: 10 m, chairs, plastic fasteners, Chapel of Saint-Louis, Pitié Salpêtrière Hospital, Paris, France

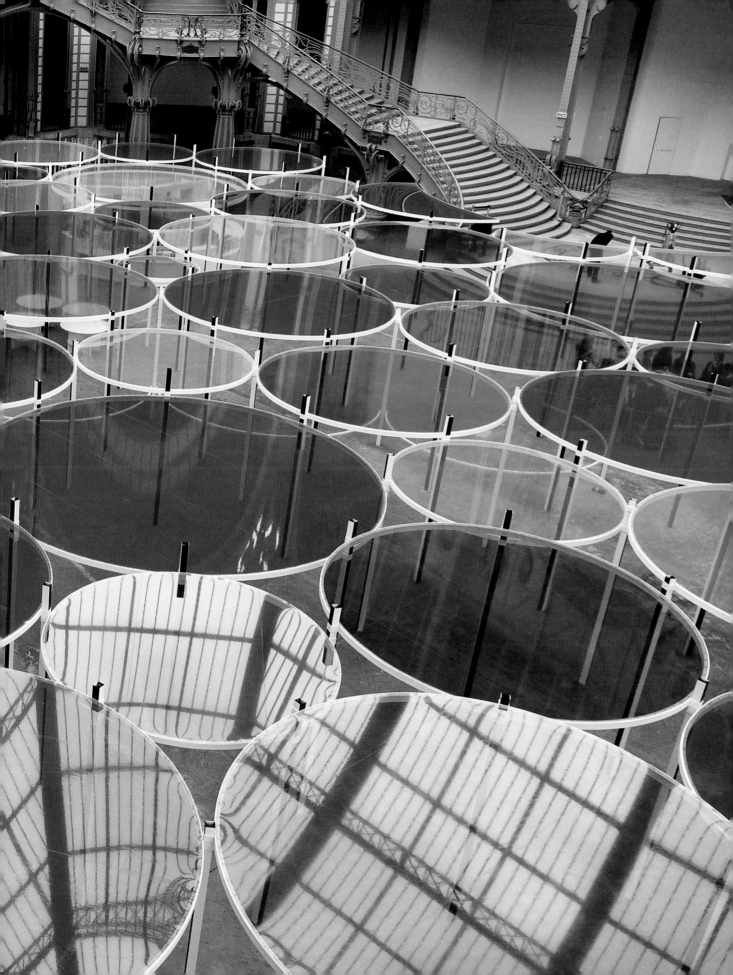

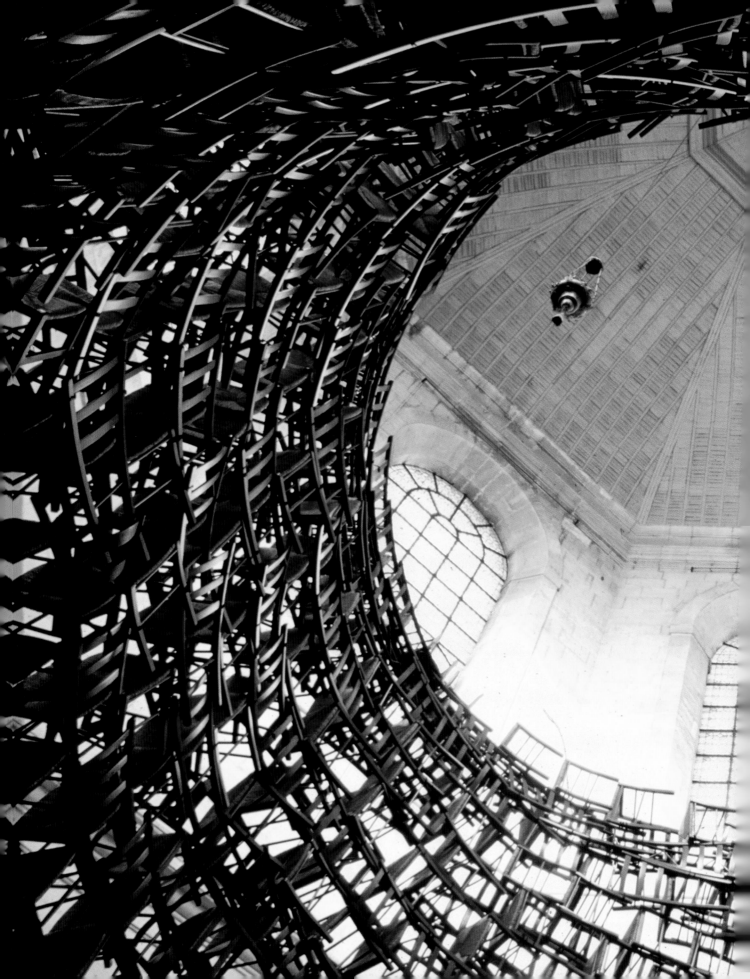

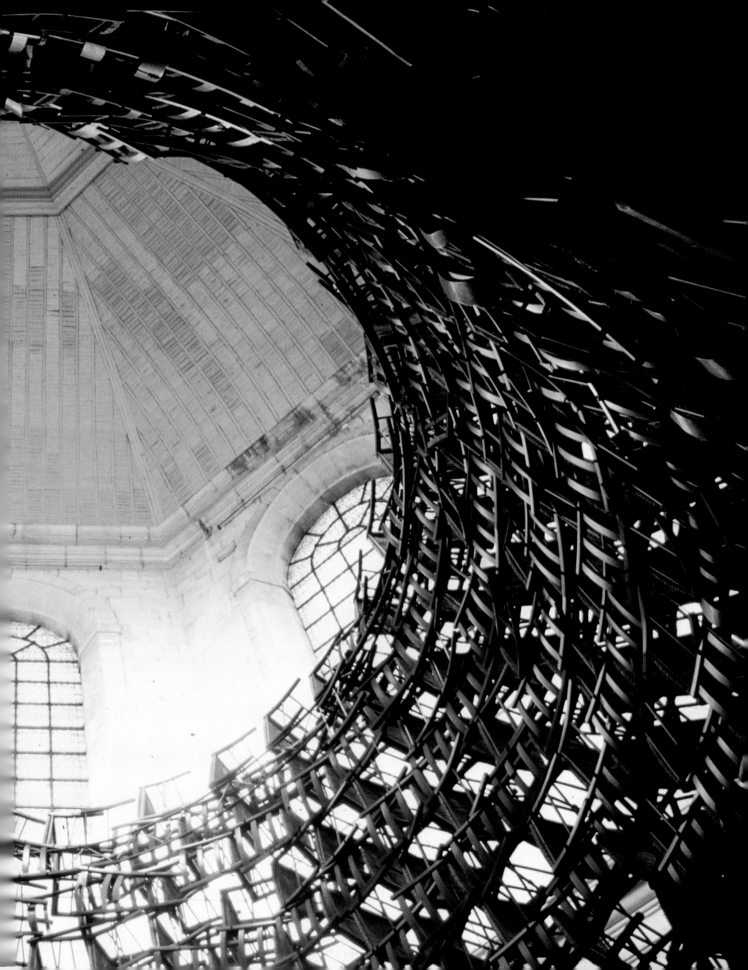

YAYOI KUSAMA

(b. 1929)

Yayoi Kusama herself qualifies her artwork as obsessive. It is based on the repetition of motifs displayed in various ways. In 1960, she wrote in her *Manifesto of Obliteration*: "My life is a dot lost among thousands of other dots." The artist has been fascinated by round shapes since her childhood, and circles and polka dots can be found in many of her works, notably in *Dots Obsession* or *Infinity Mirrored Room—The Souls of Millions of Light Years Away*.

Yayoi Kusama was born and grew up in Japan in a strict, conservative family, and she attempted to tame and externalise the hallucinations and neuroses of her childhood through art. She explains her fixation as an artist quite openly with the following memory: "One day I was looking at the red flower patterns of the table-cloth on a table, and when I looked up I saw the same pattern covering the ceiling, the windows and the walls, and finally all over the room, my body and the universe. I felt as if I had begun to self-obliterate." Haunted by the memory of this hallucination, the artist renders these dots again and again, in different colours and spaces and on various media. Obsessive, certainly, but definitely not monotonous; in the course of her long artistic career, Kusama has created work of astonishing variety: sculptures, happenings or poetry, to name but a few. In 1957, she left Japan for the United States where, as part of the New York avant-garde, she was indirectly involved in the birth of pop art and environmental art. In 1973, suffering from mental exhaustion, she returned to Japan, and since 1977, has lived in a psychiatric hospital there, while continuing to devote herself to her art. In November 2013, the David Zwirner Gallery organised an extremely successful exhibition of Kusama's art. People had to queue for hours to get in. The most popular work was *Infinity Mirrored Room*: this installation plunges the visitor into a dream world ; of course, it is one full of polka dots. A chamber is equipped with mirrors and LEDs that flicker and pulse in varying rhythms; sometimes there are so many twinkling lights that they create the illusion of infinite space. The lucky ones who braved the queues and managed to see the work say that it left them with a calming feeling that bordered on the meditative.

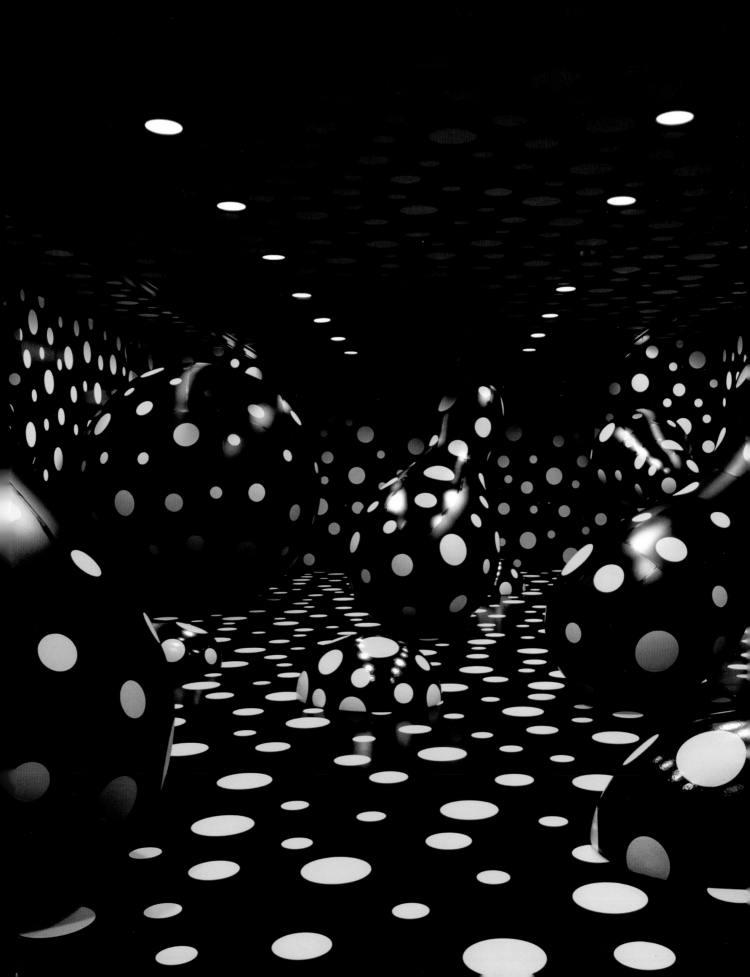

JAMES
TURRELL
(b. 1943)

For more than half a century, James Turrell has used light and space as his artistic materials, creating monumental works of art which literally *fill* the rooms in which they are exhibited.

A keen aviator—he obtained his pilot's licence at the age of 16—, James Turrell soon became interested in the "paintings" offered by the sky, creating his "Skyspaces," rooms, often entirely closed off, and with an opening in the ceiling forming a skylight. By manipulating the natural light, framing the sky at his will, the American artist changes our perceptions and offers new sensations. In 1974, he began his ongoing monumental project *Roden Crater*, in the heart of Arizona, turning the crater of an extinct volcano the size of Manhattan Island into a huge naked-eye observatory which will accommodate a series of Skyspaces.

Turrell is also a sculptor of artificial light (ambient lighting, neon light, LED lamps …), notably in *Bridget's Bardo* and *Breathing Light*. These two works are part of the series "Ganzfeld" (German for "complete field"). The term is derived from the phenomenon of the same name which manifests itself in the loss of depth perception, creating the impression of "seeing black" or perceiving everything through a white veil. The artist reproduces this effect using rooms filled with artificial light which may change from blue to red, passing through pink,

" LIGHT IS THE MATERIAL I USE, PERCEPTION THE MEDIUM. MY WORK HAS NO SUBJECT, PERCEPTION ITSELF IS THE SUBJECT. THERE IS NO IMAGE, BECAUSE ASSOCIATIVE THINKING DOES NOT INTEREST ME. "

grey or orange. These colours envelop space and erase contours, creating an artificial universe which distorts our sensory perceptions. These works are based on the idea put forward in the allegory of Plato's Cave, namely that our reality is solely the product of our perceptions. Totally objectified, the light invades the space and seems almost palpable. The viewer finds himself immersed in the work; disoriented by the absence of perspective and spatial points of reference, all he has to do is allow himself to be absorbed by the light in order to gain the sensory experience proposed by the artist.

Bridget's Bardo, 2009,
700m², height: 11 m, Art Museum, Wolfsburg, Germany

Following double page: *Akhob,* 2013,
111m², artificial lighting, Louis Vuitton City Center, Las Vegas, United States

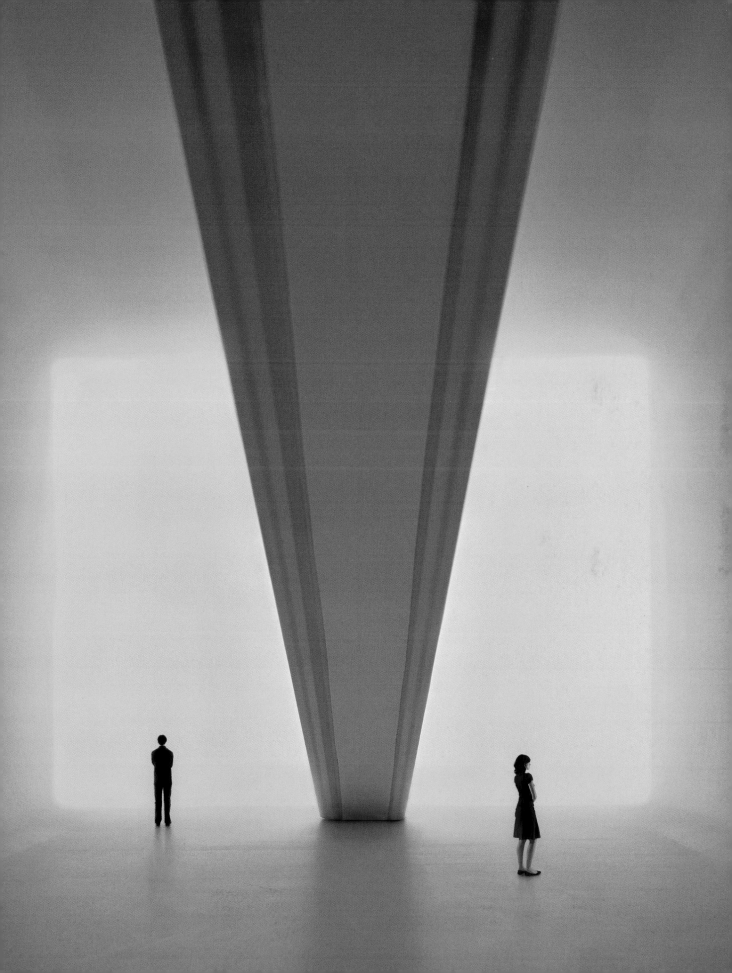

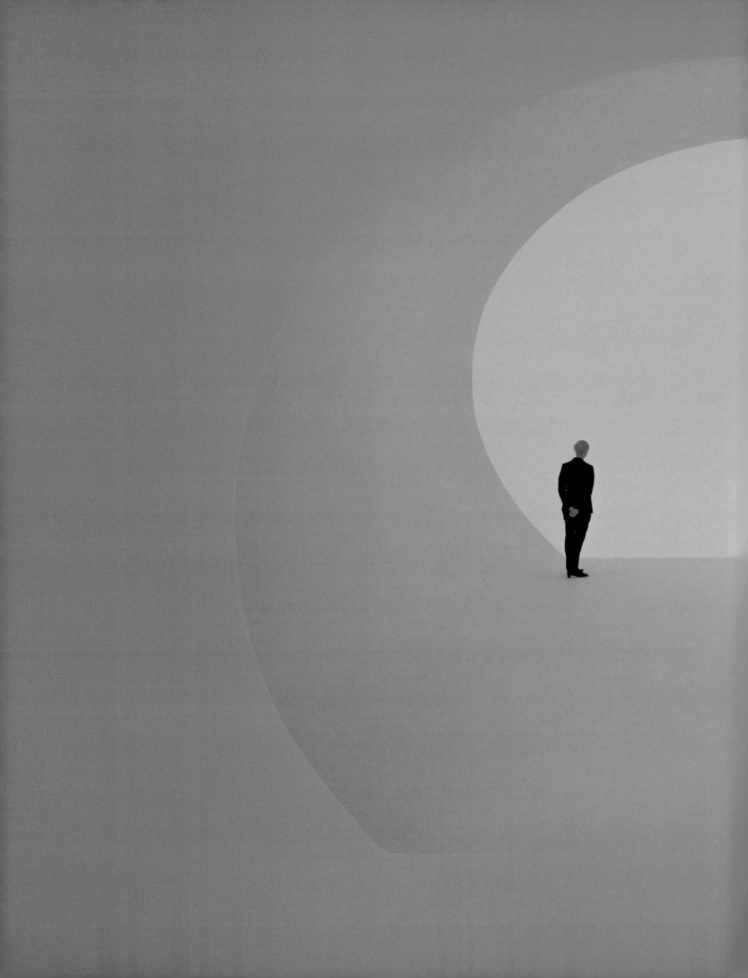

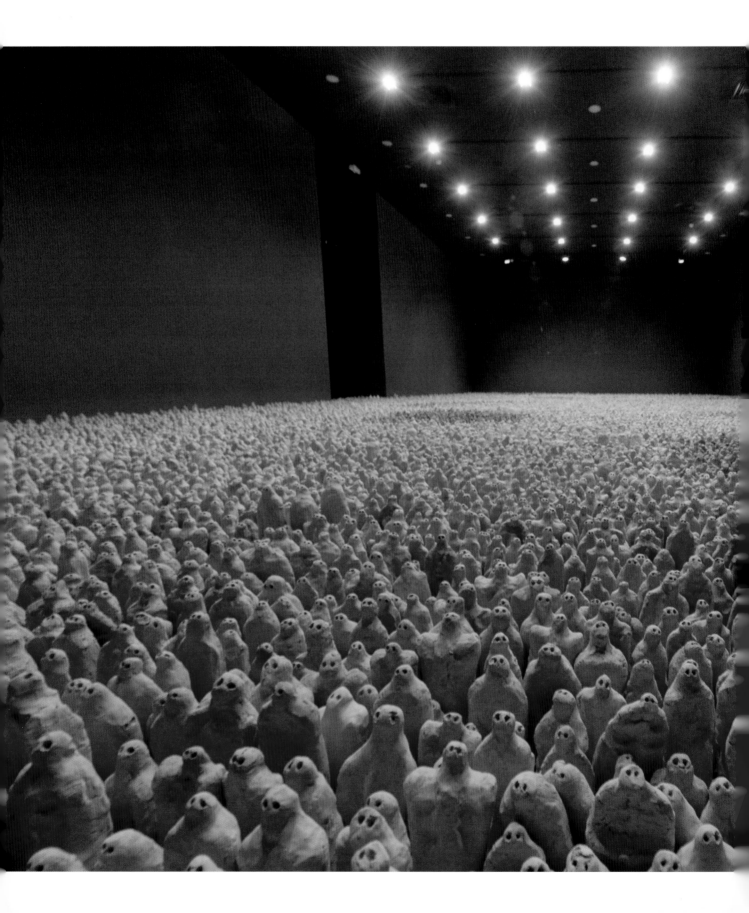

ANTONY GORMLEY

(b. 1950)

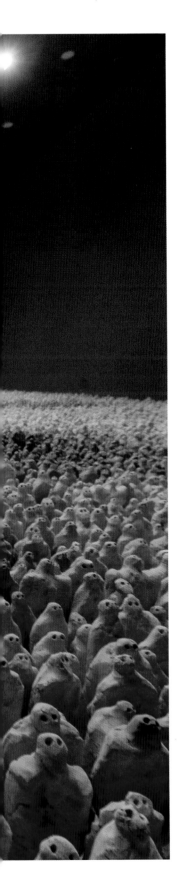

Antony Gormley is a British sculptor whose work examines the relationship between the human body and space. Starting with his very first works in the 1970s, he took his own body as a source of inspiration and takes pleasure in using it in his sculptures and often monumental public installations.

Amazonian Field went on display for the first time in 1992 in Brazil, on the occasion of the Rio Earth Summit. Antony Gormley created this work, comprising 24,000 terracotta figures made from 20 tonnes of clay, with the help of some hundred inhabitants of Porto Velho. In 2012, the work returned to Brazil for the first time.

This accumulation of human figures is not unique in Gormley's œuvre; he has created various other *Fields* since 1989. In each country he visits (Mexico, Sweden, China, Japan, Australia…), the artist asks the inhabitants to manufacture the thousands of statuettes he needs. The most impressive project was in Guangzhou, China in 2003: no less than 200,000 figurines were made, using 125 tonnes of clay. In each installation, these small human-like figures completely fill the space in which they are installed, blocking access to all visitors. The spectator, turned back at the threshold, finds thousands of pairs of eyes staring at him: here, art is judging the observer, not the other way around.

Breathing Room IV is one of these artistic reflections on the human body. The work highlights the fact that man is the only animal that lives in constructed environments entirely reliant on the geometrical principle of orthogonal spaces. Phosphorescent aluminium tubes are arranged in the centre of the room, creating an architectural structure which the viewer can enter. This space is alternately plunged into darkness and punctured by blinding light. This immersive experience both demonstrates the limits of our visual perception and questions the real character of this architectural space.

Amazonian Field, 2012,
height: 4 to 40 cm, clay, approximately 24,000 figurines, Centro Cultural Banco do Brasil, Brasília, Brazil

Following double page: *Breathing Room IV,* 2012,
300 × 836 × 1150 cm, made from aluminium tubing 25 × 25 mm, phosphorescent paint,
Centro Cultural Banco do Brasil, Brasília, Brazil

FELICE VARINI

(b. 1952)

This is not a chessboard; the work, installed for the exhibition "Versailles off" bears the misleading title *Huit Carrés* (*Eight Squares*): it is a collage with variable forms which plays with perspective by means of an optical illusion. Thanks to Felice Varini's talent for deceiving the eye, the viewer sees squares that do not exist.

Franco-Swiss artist Felice Varini is a master of anamorphosis. This visual phenomenon describes an image distorted to the point of being unrecognisable, but which takes shape when seen from a specific and very limited vantage point or through the use of a tool such as a mirror. Spectators can only see the complete work *Huit Carrés* from one angle. Once they move away from this point, they will see only fragmented blue shapes in a seemingly random arrangement. Varini explains the importance of the spectator's vantage point in his work: "The vantage point will function as a reading point, that is to say, as a potential starting point to approaching painting and space. The painted form achieves its coherence when the viewer stands at the vantage point. When he moves out of it, the work meets with space, generating infinite vantage points on the form." He adds that his work does not consist solely of the perspective as seen from the "reading point" and that it takes place in the set of vantage points the viewer can have on it. The unbelievable thing about *Huit Carrés* is that it is not two-dimensional: these squares are not in fact hanging in the passageway. As viewers move around, they can see that they are actually flat shapes attached to the ceiling and the walls. And the artist is no beginner: in the course of his thirty-year career, he has created many such large-scale optical illusions, always taking his inspiration from the architecture of the location. Rooms, arcades or building façades; no space is too big. He explores the space, finding out about its history and characteristics, before the idea for the work is born.

" I WORK HERE AND NOW. "

Huit carrés, 2006,
paint, Orangerie of the Palace of Versailles, Versailles, France

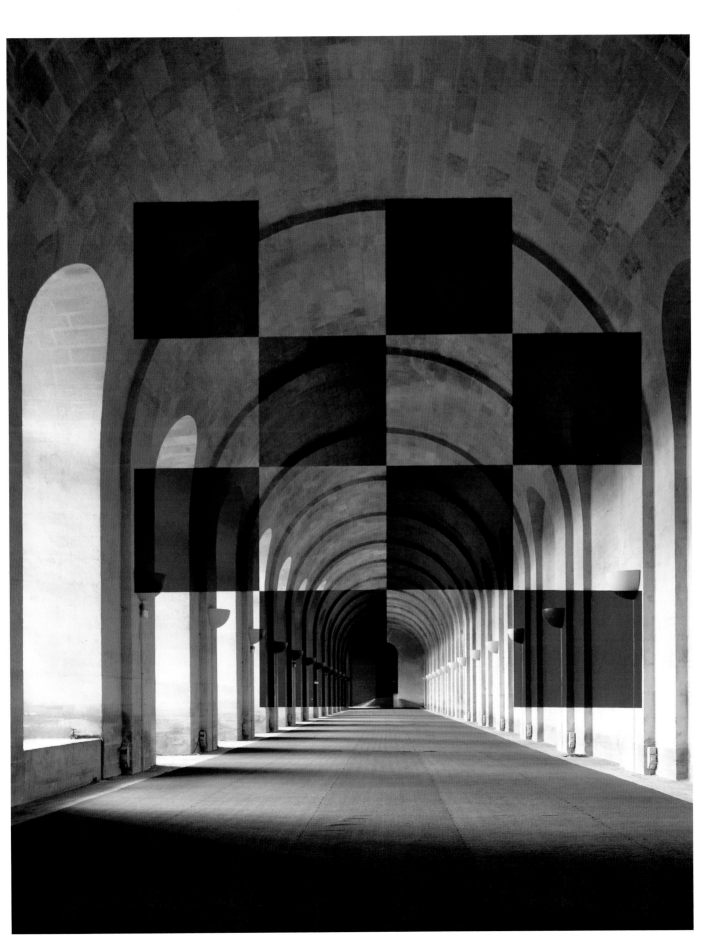

TADASHI
KAWAMATA
(b. 1953)

Tadashi Kawamata creates site-specific installations, primarily using wood. A Japanese-born sculptor living in Paris, his chaotic, random and ephemeral works prompt the viewer to reflect on the locations in which they are installed.

Tadashi Kawamata studied at the Tokyo Fine Arts University and at first specialised in painting, until he found he was more interested in the supporting material or the frame than in the canvas itself. He created his first projects using wood—frames, to be more precise—in the late 1970s. He came to use this material, which he considers easy to work with and inexpensive, in practically all his artworks. Spanning the themes of urban development, architecture and sculpture, his installations are always designed with the specific location in mind and with a view to creating a dialogue between his art and the pre-existing structures. He realises all his projects in almost identical manner: he develops the idea *in situ* and surrounds himself with students, local inhabitants and amateurs or professionals who participate in setting up and creating the work. The installations are often temporary, with their subsequent dismantling forming an integral part of the artwork. *Gandamaison*, a characteristic work by this Japanese sculptor, features a cascade of 5,000 wooden fruit and vegetable crates spilling from the roof of the Maréchalerie, the Contemporary Art Centre of Versailles. The random surge of wooden crates forms an intriguing contrast with the solemn architecture of the building, prompting visitors to perceive the location in a new way.

Le Passage des chaises (see pages 140–141), installed in 1997 in the Salpêtrière, reveals another common feature of the artist's work: the use of humble materials. Here, more than 3,000 chairs and church pews have been attached to each other and rise up in a spiral towards the domed roof of the chapel. The installation, situated in the passage leading from the chapel towards the hospital itself, invites the spectator to reflect on the connection between the two locations. "Each of these chairs is a different character with a different story; it is as if we connected the people together with plastic ties …," the artist says. Kawamata used some of these chairs again in 1998 for an installation in the synagogue at Delme (Lorraine). In addition to creating a passage between Christianity and Judaism, the artist highlights the lost meaning and identity of the location.

Gandamaison, **2008,**
approximate height: 8 m, various dimensions, wooden crates, plastic fasteners,
La Maréchalerie, Versailles, France

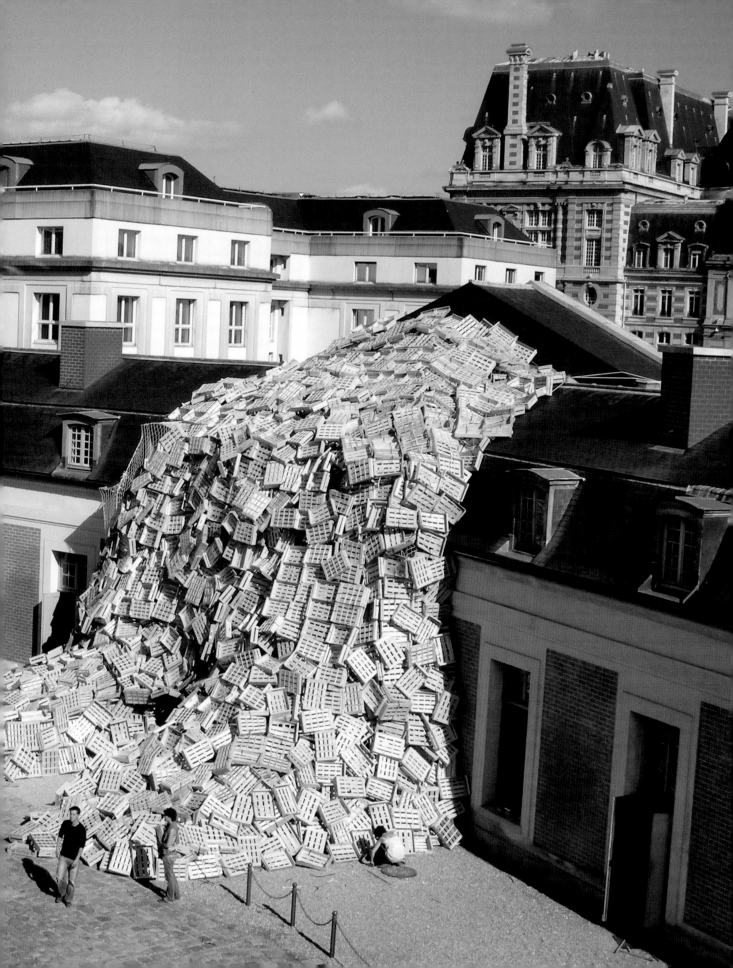

ANISH
KAPOOR
(b. 1954)

Originally from Mumbai in India, British artist Anish Kapoor settled in London in the early 1970s. He is considered to be one of the most important sculptors of our age, his work is acclaimed worldwide, and he captivates audiences everywhere with his innovative vision of sculpture.

Kapoor likes to play with curves and our perception of space. In 2006, he created *Cloud Gate* (see pages 54–55), affectionately nicknamed "The Bean." The sculpture, a popular landmark of Chicago, measures 20 metres in length and is 13 metres high. Made of welded stainless steel plates, its highly polished surface mirrors and distorts the city skyline, and many people come to admire it and take photos of their warped reflections. Just as colossal in size at 25 metres high and 85 metres long, *Dismemberment Site* I (see pages 12–13) was commissioned by a patron and collector of the arts for his open-air sculpture park Gibbs Farm in New Zealand. Created in 2009, the structure consists of a composite membrane stretched between two steel ellipses. Its bright red colour clashes violently with that of the sky and the green park surrounding it, but the impression is softened by the rounded lines that make it look a little like a trumpet. Anish Kapoor emphasises the corporeal aspect of his work: "It's the colour of the inside of our body. It's an internal red that externalises itself in a way," he explains. Designed to be a permanent installation, it draws a new horizon, and with its curved contours, it integrates itself into the panorama of the rolling hills surrounding it. *Leviathan* fascinated visitors to the Grand Palais in Paris during a five-week exhibition in 2011. Kapoor invited people to enter an enormous, deep purple, inflatable structure. Inside, they found themselves in a huge, womb-like space rendered a translucent red by the light outside. Once again, Kapoor reached out to the public, inviting them to interact with his work.

Opposite and following double page:
Leviathan, **2011,**
34 × 100 × 72 m, PVC, Grand Palais, Paris, France

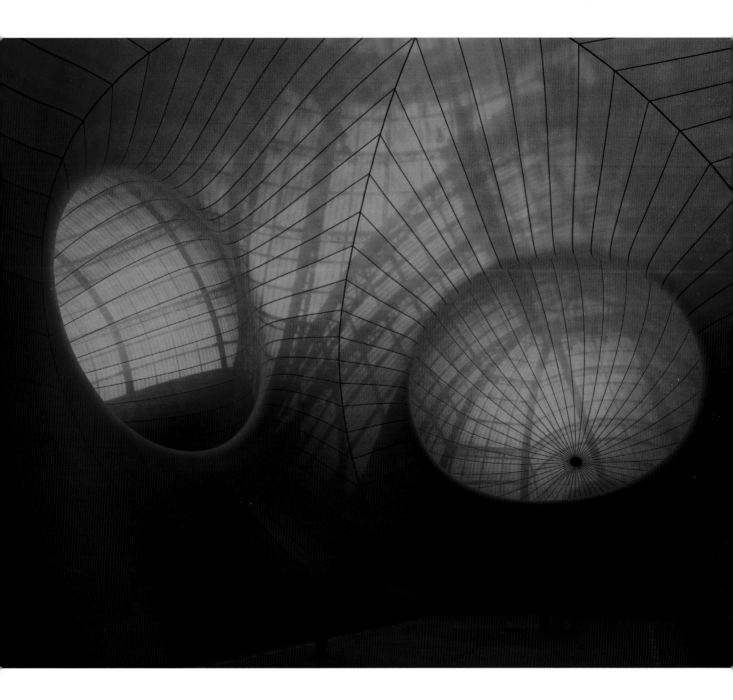

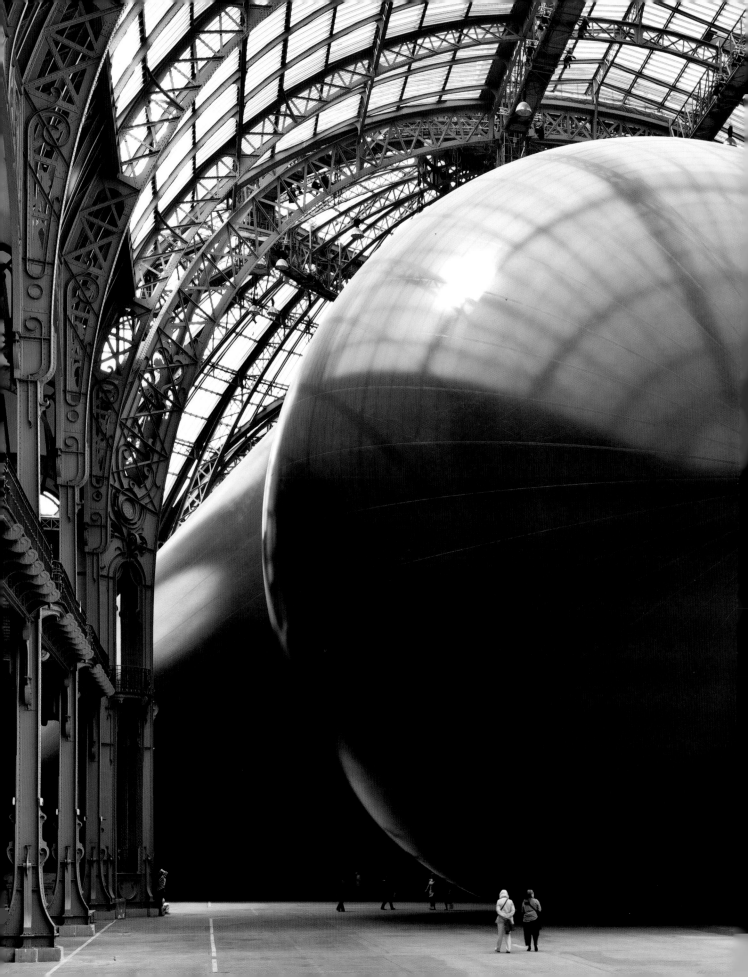

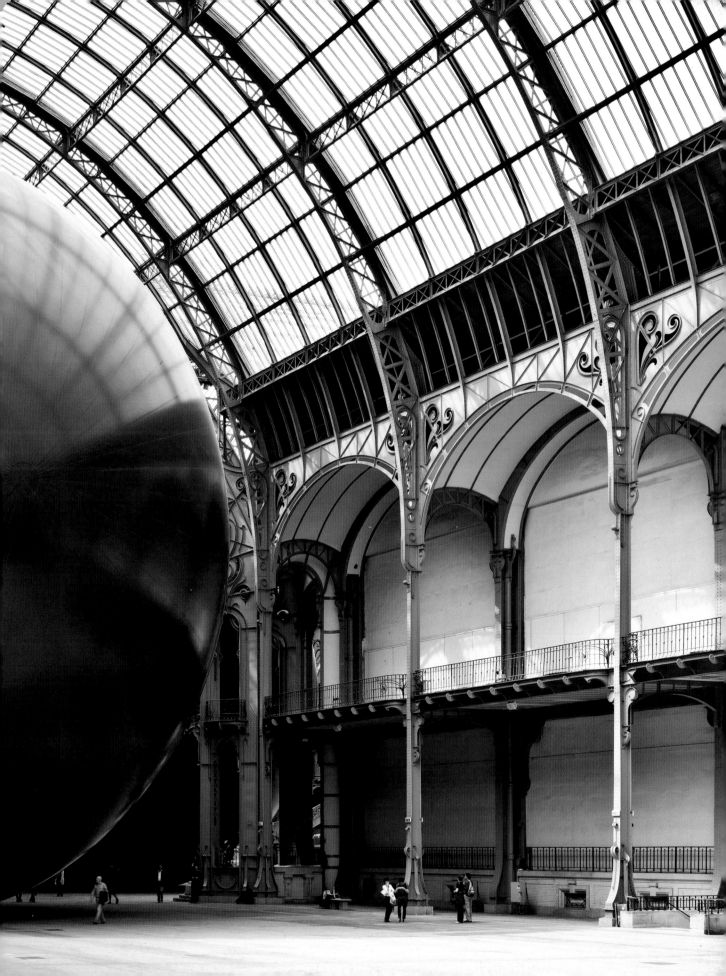

AI
WEIWEI
(b. 1957)

Ai Weiwei is a rebel artist who uses his art to bring about change. Although his work has frequently brought him into conflict with the Chinese authorities, he continues to create and exhibit it. *Sunflower Seeds* and *Forever Bicycles* are gigantic works with a profound meaning that transcends all borders.

In 2010–2011, for a period of seven months, *Sunflower Seeds* was on display at the Tate Modern in London as part of the Unilever Series: 100 million sunflower seeds poured onto the floor of the Turbine Hall. Although they look realistic, each seed is in fact made from porcelain, hand-crafted and -painted by skilled artisans from Jingdezhen—which has been the global capital of the porcelain industry for centuries—where the trade is currently in grave crisis. In addition to providing work for workshops under threat of closure, Ai Weiwei's work raises numerous questions with regard to his country: mass-production, the place of the individual in society and the place of the artisan in a world which frequently favours over-consumption at the expense of quality… The work points out that "made in China" does not always mean industrially produced goods of inferior quality, but that in China, there are still valuable traditional techniques in which the future of commerce may lie. It is also a reference to propaganda images representing Chairman Mao as the sun and the Chinese people turning towards him like sun-flowers. In January 2011, the Chinese authorities demolished Weiwei's workshop in an attempt to intimidate him. Then, in April, he was arrested and imprisoned in an unknown location for 81 days. Refusing to be gagged, he staged an exhibition in Taiwan which opened in October 2011 and defiantly entitled "Ai Weiwei Absent," in protest against being banned from leaving the country. The core exhibit is an installation comprising 1,000 bicycles with their saddles and handlebars removed. *Forever Bicycles* is a translation of the name of China's most popular bicycle brand. Once again, the public is invited to reflect on mass-production. These mutilated and precisely aligned bicycles can also be seen as symbolising the deprivation of liberty. An extremely popular means of transport in China, these immobilised bikes here form a labyrinth which encloses rather than providing a means of travelling. In 2014, Weiwei's passport still has not been returned to him…

Sunflower Seeds, 2010,
exhibition 152 m long, porcelain and paint, Tate Modern, London, United Kingdom

Following double page:
Forever Bicycles, **2011,** height: 10 m, 1,200 bicycles, Taipei Fine Art Museum, Taipei, Taiwan

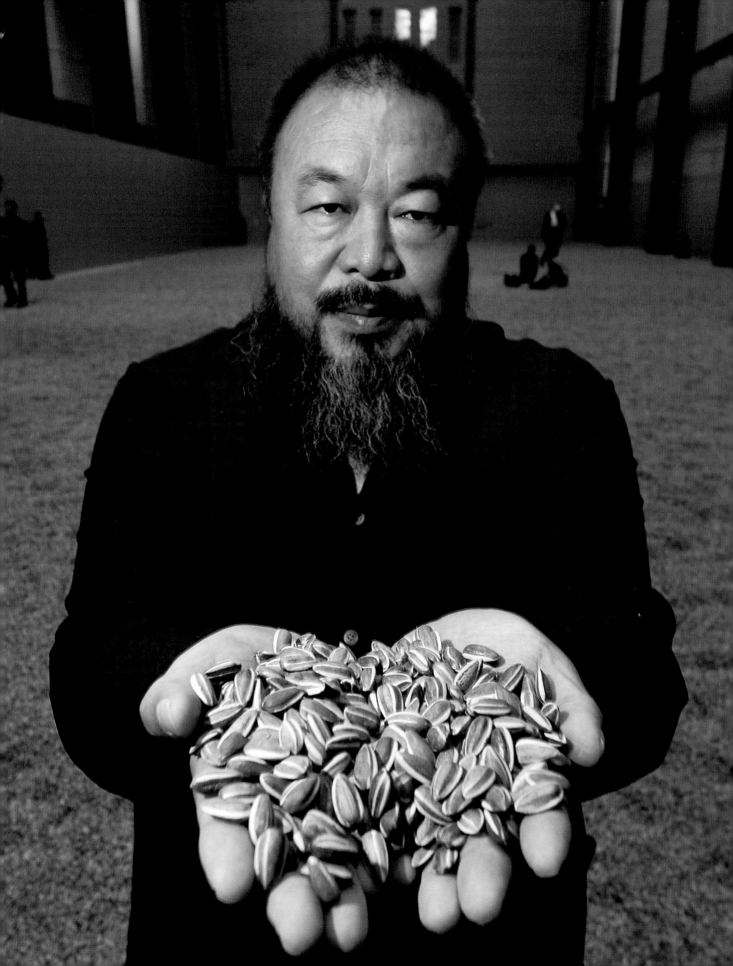

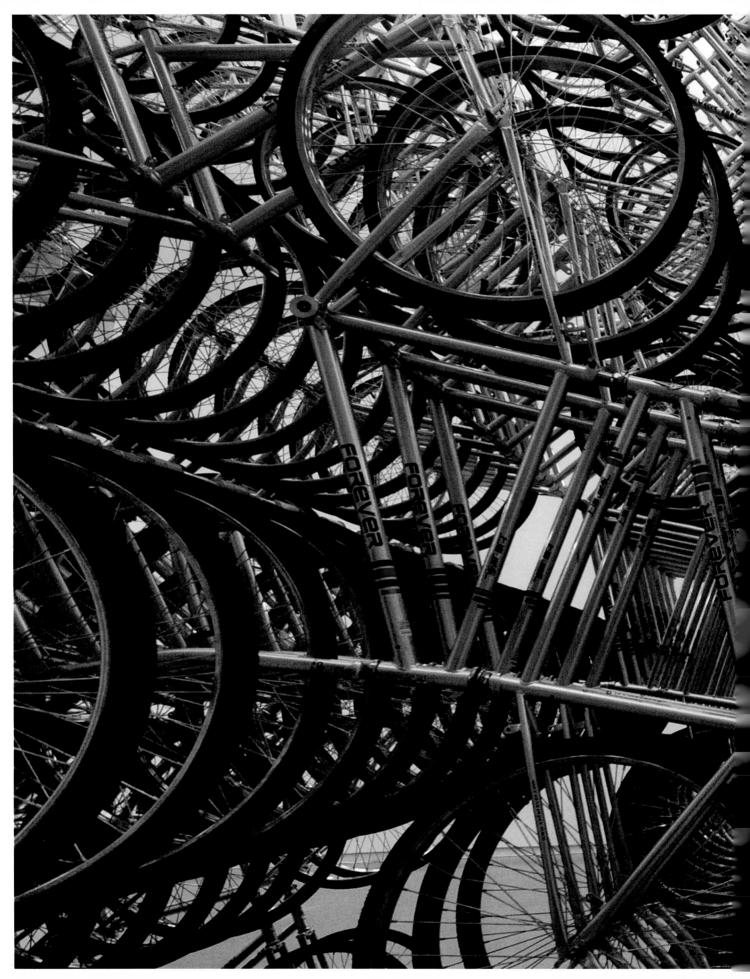

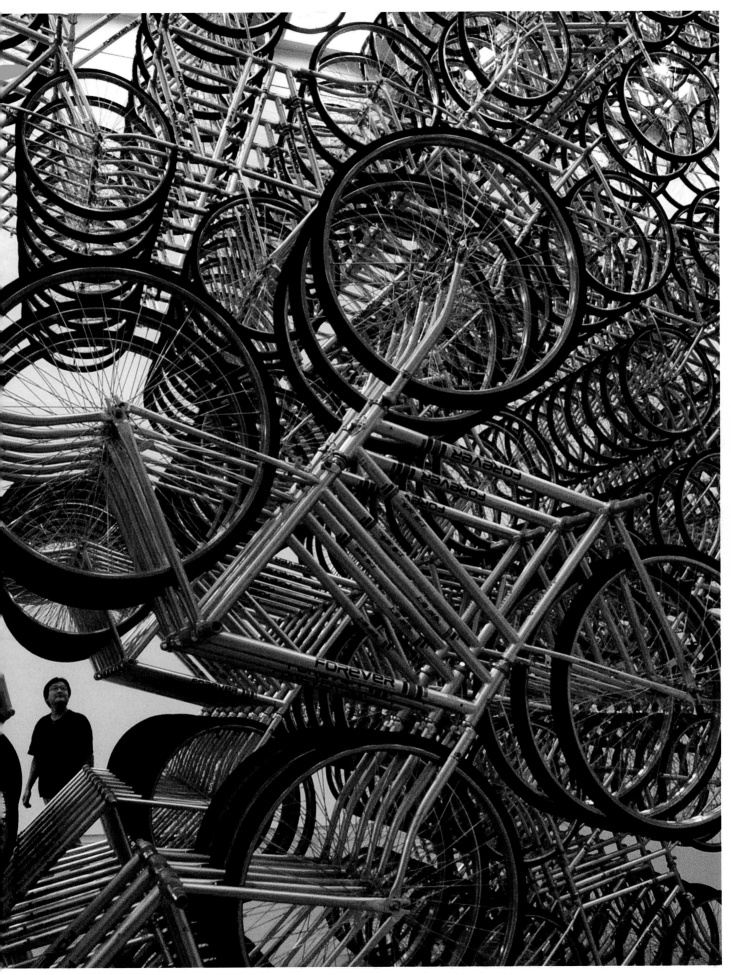

DORIS
SALCEDO
(b. 1958)

Every year, the Turbine Hall of the Tate Modern in London hosts a new monumental art installation (see Ai Weiwei, pages 162–165). In 2007, visitors could admire *Shibboleth* ('The Crack'), a hyper-realistic fissure, 167 metres long and sixty centimetres deep, zigzagging down the centre of the room. The meaning of the work is intriguing, but it was its method of construction that particularly attracted attention.

Rather than filling the space with a conventional sculpture, Doris Salcedo created a gulf that stretched the full length of the Turbine Hall. By making the floor the focus of her project, she offers a new representation of space and architecture. But *Shibboleth* is more than a reflection on art and space; it is a committed work of art. "Shibboleth" is a reference to the Bible story of the inhabitants of Gilead, who identified their enemies, the Ephraimites, by asking them to say this word, which the latter were unable to pronounce correctly; the term came to mean a word or phrase that is used to distinguish members of a group from unwelcome outsiders. Across this fissure in the floor, the Columbian artist conveys the message that the progress and prosperity of western society has deepened the gulf between it and poorer nations. She exposes the division of the modern world, the gap between North and South. *Shibboleth* is also a protest against racism; it depicts the experience of immigration and segregation. The artist is warning us to be on our guard: this gulf is becoming steadily wider and deeper and may in the end bring the entire edifice of our society crashing down around us.

Many interviewers have asked Doris Salcedo how this work was constructed, but the artist has always replied evasively. For her, the important point "is the meaning, not the production process." Journalists revealed that the sculpture was made in Bogota and then transported in sections to London, at high cost. This disclosure scandalised certain critics who already disapproved of this work, which they considered "dangerous." And indeed, the *Times* reported that several people suffered minor injuries during the exhibition, despite the fact that signs were put up warning visitors: "Caution: danger of falling."

Shibboleth, 2007,
length: 167 m, concrete and metal, Tate Modern, London, United Kingdom

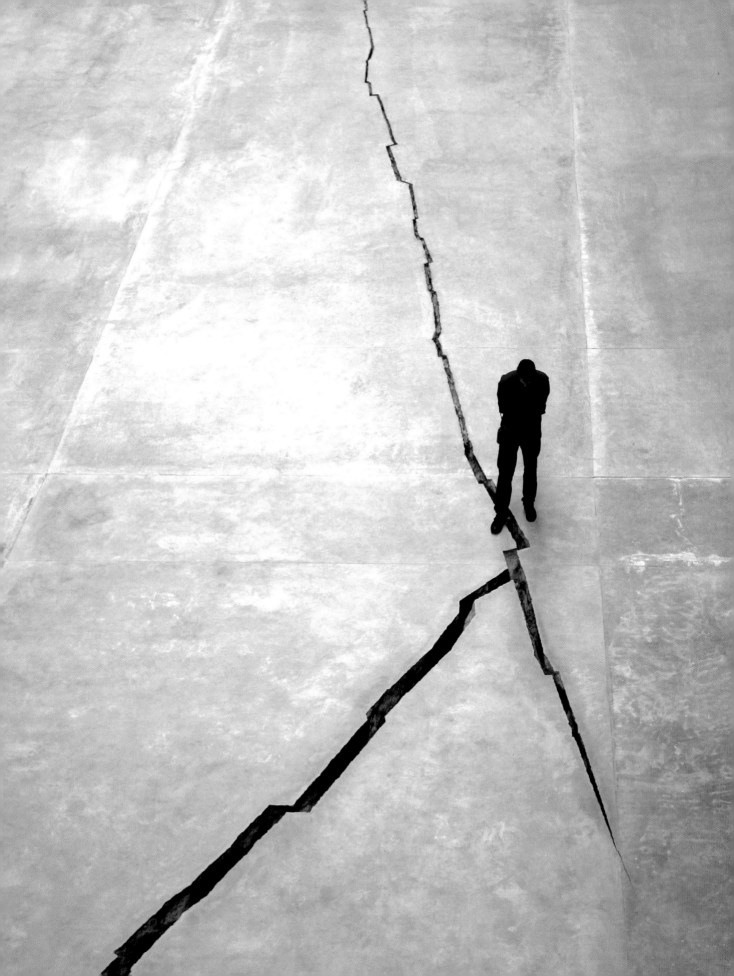

KRIJN
DE KONING

(b. 1963)

Like an invasive climbing plant, the art installations of Krijn de Koning fill the space they inhabit: walls, floors, ceilings... the young artist from the Netherlands covers everything! But far from destroying or changing the nature of the location, his intention is to invent it anew, thus inviting the spectator to reflect on the manner in which he occupies it.

In the 1970s, artists like Daniel Buren (who, by the way, de Koning associated with for several years) or Michael Asher were the first to take the exhibition location and treat it as an integral part of their art. Krijn de Koning's is a direct development of this theme of works *in situ*. Mainly temporary installations, his works are always installed on a pre-existing structure which is often monumental. They line walls, invade staircases, conceal areas of the floor under large monochrome platforms made of plaster, cardboard and even wood. Museums, galleries, patios ... this minimalist visual artist installs his colourful dividing walls wherever he is granted permission to do so, thus modifying our perception of the location and creating a new architecture which prompts the viewer to experience space in a different way.

In 2006, Krijn de Koning was invited to exhibit at the abbey Saint-Léonard de Corbigny. He installed two works there: one in blue in the former kitchen and one in yellow occupying the main stairway. The majestic staircase was completely metamorphosed: the artist transformed an austere flight of stairs which seemed frozen in the past into an entertaining and colourful pathway inviting people to linger and wander there, almost as if they were in a maze. In initiating a dialogue between two historical times, Krijn de Koning invites reflection on our heritage. Like the majority of his works, the yellow staircase was a temporary installation which was later dismantled, restoring the space to its former state. However, it is still possible to admire the *Work for the Abbaye de Corbigny (blue)* in the kitchens, as this work was acquired by the Frac Bourgogne in 2007.

Above:
Work for the Abbaye de Corbigny (yellow), 2006,
5.84 × 4.8 × 3.6 m, wood, acrylic paint, Abbey of Corbigny, Corbigny, France

ERNESTO NETO

(b. 1964)

Whatever has happened to the hallowed halls of the Panthéon in Paris? These troubling oblong shapes hanging from the ceiling are the work of Ernesto Neto, a bold and exceptional sculptor whose preferred themes are the human body and sensuality.

The leader of the contemporary Brazilian art scene, Ernesto Neto describes his works as arising from "a sensuality of the moment and of space." Using malleable and transparent materials reminiscent of the skin—"epidermic" materials—and spices, he invites the spectator to experience art intensively with all their senses. His work is not dominated by the visual aspect, but incorporates the olfactory, aural and tactile: visitors are encouraged to smell the scent of lavender or cumin, to hear the sand crunching beneath their feet, to touch the voluptuous forms, to stretch out on them, to feel soft shapes through openings in the sculptures … By engaging all of their senses, they become one with his art.

In 2006, when he was invited to exhibit in the Panthéon, Ernesto Neto was hesitant: he found this "temple of rationalism" far too solemn with its neoclassical architecture, its tombs and its Foucault pendulum. But he took up the challenge and created *Léviathan Thot*, a huge, anthropomorphic, rounded, sensual work floating beneath the domed ceiling. This giant, mobile sculpture, made with four tons of sand, polystyrene and lavender was designed as an interactive work appealing to all the cognitive faculties. In it, Neto managed to bring together the Leviathan (his sculpture), the biblical sea monster representing absolute evil,

HE [THE POET] MUST MAKE HIS INVENTIONS FELT, TOUCHED, HEARD.
Letter from Arthur Rimbaud to Paul Demeny, 15 May 1871

and Thot (the Panthéon), the Egyptian god who invented the system of writing and symbolised order. But the equilibrium between them appears fragile, and the arrangement of the work, suspended in space, calls for balance.

A celebration of enjoyment and the present moment, the work nevertheless invites more profound reflection: the artist aims to point out that our society is experiencing a transition at least as violent as that from a monarchy to a republic (which is embodied by the Panthéon).

Léviathan Thot, **2006,**
various dimensions, lycra tulle, polyamide fabric, polystyrene beads and tubes, bags of sand, Panthéon, Paris, France

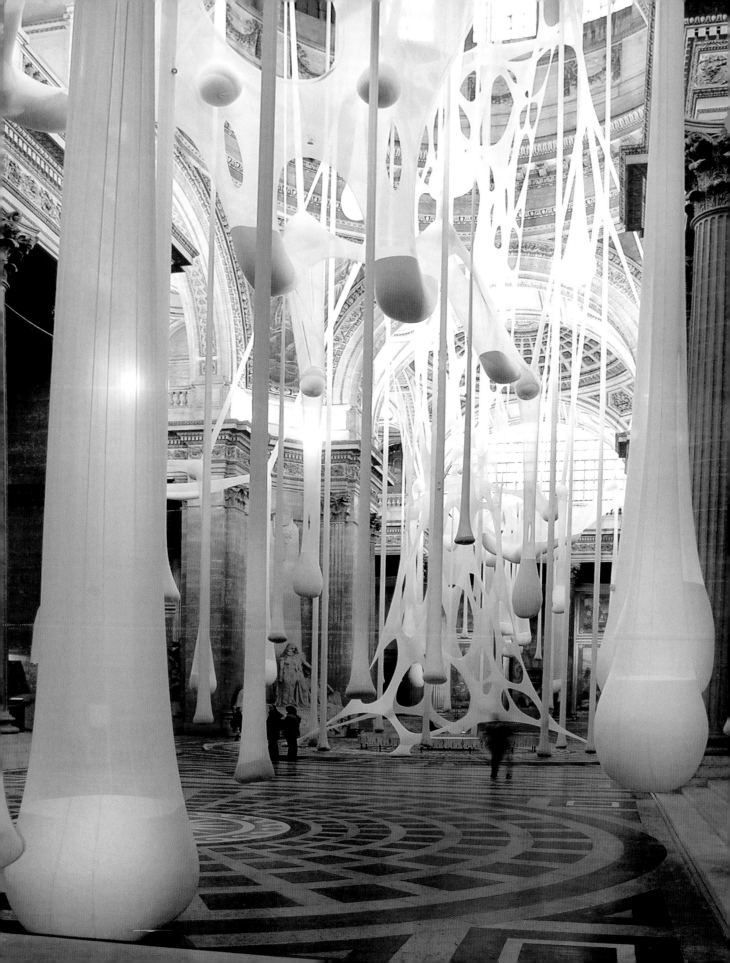

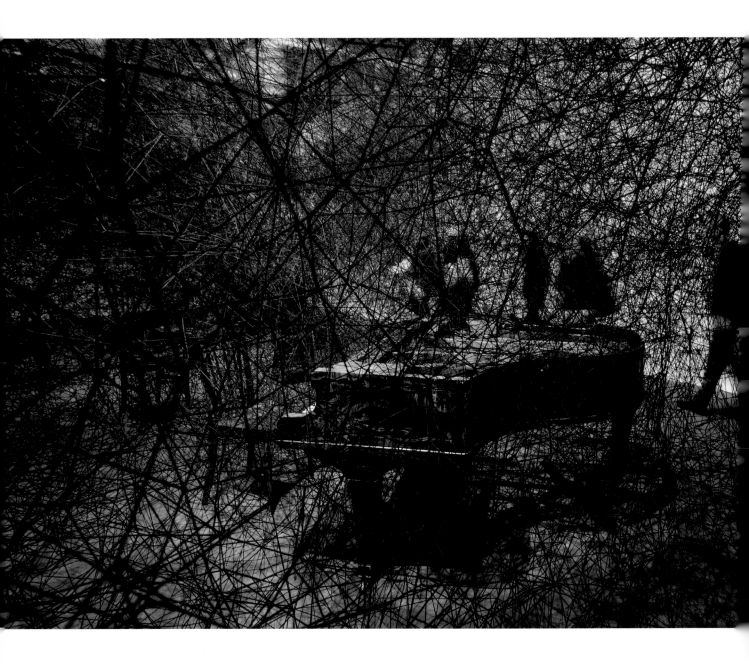

CHIHARU SHIOTA

(b. 1972)

Chiharu Shiota's work is poetic and monumental and is somewhere between performance and installation. When she is not filling rooms with kilometres of interwoven threads, this Japanese artist expresses her ideas through spectacular accumulations of everyday objects (shoes, suitcases bed frames…).

Chiharu Shiota created her first works using woven threads in 1996. These installations using red or black threads represent a reflection on remembrance and oblivion, the past, dreams and memories. The artist encloses objects with personal significance in this cocoon of threads: wedding dresses, musical instruments, books. Sometimes, she even entwines herself, like a spider caught in its own web. The threads represent her emotions at the moment when the work was created: they are often feelings of fear and anguish.

Insilence is an installation-performance presented in 2011 in the Detached gallery in Hobart, Tasmania. Chiharu Shiota set fire to a piano in a Hobart street and transported it to the gallery, where three people were then engaged for 16 days in weaving threads around the charred instrument. When the work was completed, the piano was trapped within a labyrinth of black threads. This autobiographical work has its roots in a disturbing childhood experience. One night, when she was nine years old, the artist was woken by the sound of crackling flames

" THE THREADS ARE INTERWOVEN INTO EACH OTHER. GET ENTANGLED. ARE TORN APART. AND DISENTANGLE THEMSELVES. IT IS LIKE A MIRROR OF FEELING. "

and the smell of burning: they were forced to watch helplessly as the neighbours' house was devoured by flames. Later, the artist discovered the blackened carcass of a piano, silenced for ever, amid the ruins. Traumatised, the artist says that ever since, she has never been able to smell something burning without feeling that she has lost her voice. This work, which she has installed in several variations in other galleries, expresses the silence which floods her mind, paralysing her. The exhibition space symbolises her brain, the silenced piano her voice trapped within her body and the black threads her anxiety.

Insilence, **2011,**
140 km of woollen thread, piano, various dimensions, Detached Gallery, Hobart, Australia

DEBOMBOURG

BAPTISTE

(b. 1978)

An "accident in space" has happened in the Patricia-Dorfmann gallery in Paris. The debris of a white wall, in the process of being completely blown apart, is frozen in a transitory state, in suspension, at the very moment of explosion. This radical work is a sculpture by French artist Baptiste Debombourg, the majority of whose creations revolve around the destruction of supporting structures.

Baptiste Debombourg prefers "everyday" and "inexpensive" materials such as glass, cardboard boxes, polystyrene and even DIY furniture kits! He uses their component parts to create new objects or environments. The supporting structure is demolished after serving to fashion a new work, which may be, for example, an altar in polystyrene (*Alléluia*, 1999) or a historic monument made from cardboard (*Arc de Triomphe*, 2001). The artist finds his main source of inspiration in mundane, everyday objects which he elevates to a plane above that of the mediocre and trivial. Ennobled in this way, staples, toys and vehicle chassis require us to look at them in a different way, inviting us to examine and question our usage of them and how we relate to them. By covering a wall, or sometimes an entire room, in wood or in glass, Baptiste Debombourg modifies our perception of space.

That is exactly what is happening with *Turbo*, a chipboard wall that is collapsing as if pulverised from the inside. The work is a reflection on our desire for power and the appearance of masculine strength. Turbo, as a turbocharger in cars or as "turbofolk" in the world of music, is an almost invisible element which brings a new energy and boosts power (the power of an engine or of a rhythm). Debombourg's *Turbo* denounces a culture that seeks to acquire a power which is seen as signifying strength, a culture that tends to constantly flaunt its superiority. This work questions the striving for supremacy, because this monumental sculpture is paradox: it seems at the same time fragile and precarious. The artist's warning to us: a hunger for power often leads to failure and evil.

Turbo, **2008,**
3.2 × 7.3 × 3 m, chipboard, white melamine, Patricia Dorfmann gallery, Paris, France

ARTIST INDEX

PICTURE CREDITS